FML

WD

Oil Painting

Course of Drawing and Painting

Author: Josep Casals
Artists: Badalona Ballestà, Rogelio Urgell, Julia Romero
Editor: Nacho Asensio
Coordination & texts: Rosa Tamarit
Translation: Bill Bain
Graphic design & Layout: David Maynar / Mar Nieto

Copyright © 2004 Atrium Group
Published by:
Atrium Group de ediciones y publicaciones S.L.
Ganduxer, 112
08022 Barcelona

Tel: +34 932 540 099
Fax: +34 932 118 139
e-mail: atrium@atriumgroup.org
www.atriumbooks.com

ISBN: 84-96099-62-8
Legal Dep.: B-47.141/2004

Printed in Spain
Ferré Olsina S.A.

Contents

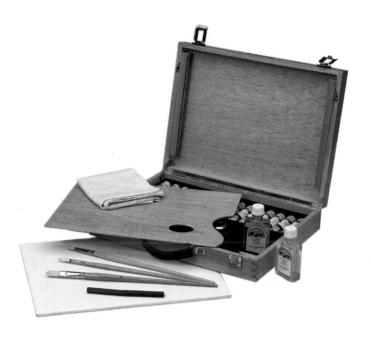

Introduction

From the middle of the fifteenth century to the present oil painting has been the indisputable queen of pictorial techniques. In spite of the advances of chemistry and of the novel products these have generated, one still never ceases to be surprised by the textures and the extraordinary vividness of color reflected by oil paintings.

Unlike what happens with water-base paints, oils take a long time to dry. Yet this, far from being an inconvenience, makes it possible to manipulate and stump the color while the paint is still fresh. Another quality that characterizes this medium is its versatility. The paints can be applied in thinned form—like a glaze—or else as a thick, covering coat. There is thus the possibility of creating a textured effect on the surface of the painting. And besides these qualities, once the painting is dry, the finish is extremely resistant and durable.

All of these advantages led to the adoption of oil paints by the great masters for their finest productions, leaving previous techniques in the background. The beginner who comes to these pages will of course be able to evoke any number of examples of oil paintings from history. They will range from surprising religious scenes of the Baroque period to the agile, light-filled "shorthand" of the Impressionists. In the face of such variety, and supposing the difficulty these pieces entail, the beginning artist's first thought may be of the I-could-never-do-that sort. Don't discourage yourself. With oils, many different styles are possible, and they aren't all reserved for the most experienced painters.

What follows in these pages is designed to teach you techniques you can use to direct your creativity and control palette, brush, and medium to put all your expressive capacity on the painting surface. Let yourself be guided, then. Experiment with materials, mix colors, forget your fears as you stand before the blank white canvas and draw a free, decisive brushstroke on it. If you change your mind, start again.

Slowly, and without thinking about time, you'll live through the incomparable feeling of painting with oil.

1 Oil paint

Painting in oil is a pictorial procedure that uses an oily, opaque, dense medium that dries slowly. Unlike watercolor, oil paint can be applied on any previously prepared surface.

First steps

THE APPEARANCE OF OIL PAINTING AND MODERNITY

Until the middle of the fifteenth century, artists painted in tempera. This technique was one that mixed powdered color (pigment) with glue or egg-size (yolks, whites, or both) to obtain tenuous colors. Once dry, these had a matte surface. The behavior of tempera over the course of time, however, tended to instability. With the appearance of oil paint, in the Low Countries, the inconveniences of tempera ended.

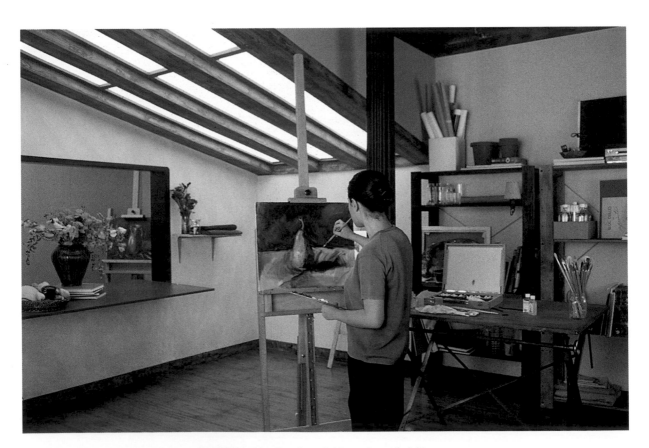

The studio of the oil painter is large and well lighted to allow the artist to work comfortably.

The present unit will describe the first steps of oil painting techniques, the way to prepare colors, and the correct use of the brush to get the lines you want.

By way of simple introduction, beginners should know that oil isn't thinned with water but with turpentine

PAINTS

Oil paints can be acquired commercially in different forms and qualities. If this is the first time you've tried this medium, it is recommendable to buy a box with an assortment of a dozen medium range colors. Don't let yourself be tempted by the cheaper ranges because their low quality may affect your good knowledge of the medium you'll be working in.

Cleaning the tubes

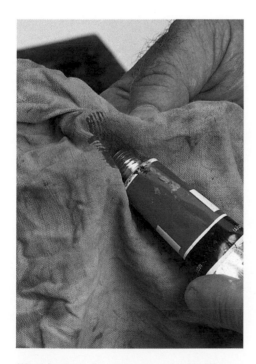

When finished with a color, clean the threads of the tube with a cloth.

Opening the tubes

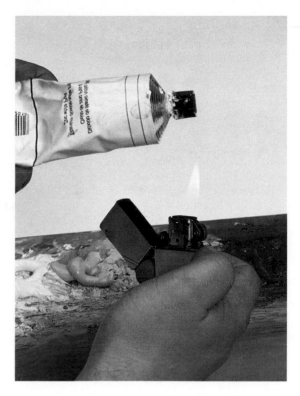

You can loosen the cap of a tube of paint by holding it close to the flame of a lighter. Be careful when you do this!

OPENING THE TUBES

When using tubes of oil paint, it is important to observe that they should be opened carefully so as not to release too much paint by squeezing too hard. When you put paint on your palette, the tube should be closed again immediately afterwards, using a brush to remove any paint remaining on the threads of the tube.

If the cap is replaced without cleaning the threads, it may be difficult to open the tube next time. If this should happen, use a lighter to heat the cap, taking care not to melt the plastic or overheat the tube.

PREPARING THE PALETTE

Once you've opened the tube of paint, squeeze from the closed end like a tube of tooth paste (never press the center—it deforms the tube) to deposit the necessary amount of color on the palette.

Oil paint spreads very well, so an amount of paint the size of a walnut or slightly smaller is enough to paint a rather large surface. The color shouldn't be placed on the center of the palette, which is reserved for mixing, but on the edge.

LOADING THE BRUSH WITH PAINT

The paint in the tube is already prepared to be used for painting.

A basic rule to remember, however, is not to bury the brush in the paint. This avoids staining the handle and overextending the paint on the palette. Just draw the brush over the blob of color at its thinnest spot and move the brush in a sweeping motion. This way the toe of the brush will be fully and uniformly loaded with paint.

TESTING THE COLOR

After loading the brush with paint, you should apply the first brushstrokes on a test surface. To do this, use a piece of white cardboard as test support.

These first tests are simply to try out a few rapid strokes to see what the different lines look like and let you get used to the oil paint medium.

If the paint is too thick, thin it by adding a small amount of turpentine. The correct way to do this is to apply the thinner to the paint and mix it with the brush until you get the texture you want. Later on we'll talk about the way to use the brush, but it's very important to know that each time you end a

To take the color from the palette, use only the toe of the brush.

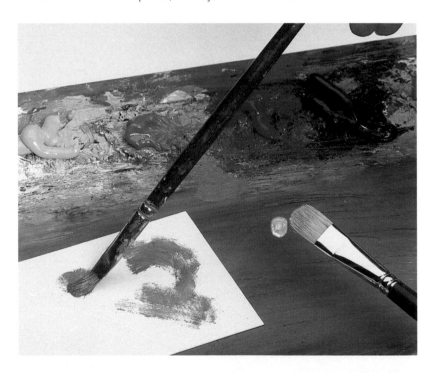

The first steps of the beginner consist in trying out a few brushstrokes on a piece of white cardboard to get acquainted with the medium.

session the brush must be conscientiously cleaned.

SUPPORT AND SPACE

To paint with oil any type of surface can be used as long as it is properly prepared. So, to start with, you can acquire small rectangular pieces of canvas (they don't have to be high quality) fixed to a board by thumbtacks.

You can also use canvas boards. In any event, since doing the tests will require several supports, it is advisable to use throwaway materials.

Note how the brush is held somewhere around its mid-point.

Turpentine

Never begin to paint in oil without having turpentine or a derivative thinner on hand. This product is used to clean brushes, remove fresh stains, and thin the paint. Oil paint is made of linseed oil and pigment and so is obviously an oily medium.

HOLDING THE BRUSH

Having spoken about the first notions on how to use the tubes of paint, the question arises of the correct way to hold and use the brush as well as the way to clean it after use.

In oil technique, the brush can be used in different ways. However it should always be held between the index finger, the ring finger, and the thumb.

Depending on how you hold the handle, you'll dominate the brush with your arm, your wrist, or your fingers. Holding the brush correctly is a basic part of being able to apply color smoothly and to dominating the line.

MID-POINT GRIP

If you hold the brush around the mid-point, you should rest the handle on your fingers and wrap fingers and thumb around it. And you don't need to press hard. This way of holding the brush gives you a lot of mobility and lets you move the color firmly. The wrist dominates this type of brush-stroke.

HAND AROUND THE BRUSH

Another way of holding the brush is by turning up your palm and resting the handle on your fingers. The brush is then held a little closer to the ferrule and acts more like a natural prolongation of the arm. You can use more energetic motions of the whole arm.

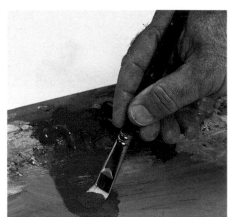

Pencil grip.

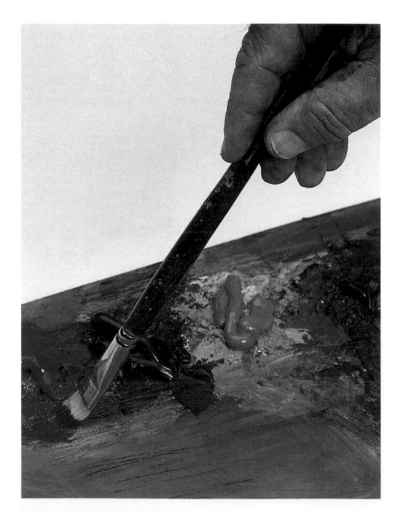

Holding the brush at mid-point

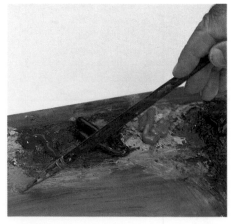

Holding the brush at the end.

PENCIL GRIP

Holding the paintbrush like a pencil allows you to control it with your fingers and wrist and get more precise strokes. The strokes can be short and rapid. This type of grip makes it possible to achieve small lines, which are ideal for representing grass, hair, wood grain, etc. on the canvas.

HOLDING THE END OF THE BRUSH

When you hold the brush by the very end of the handle you get total mobility. All the parts of your arm and hand come into play, from shoulder to fingertips.
This type of grip is basically used to draw a certain distance and it is very practical for preliminary sketches. But remember that because of the mobility the line will be very wide and the details difficult to control.

CLEANING THE BRUSH

At the end of each painting session the brush(es) must be conscientiously cleaned. Otherwise, when dry, the bristles will be stiff and impossible to clean again for normal use. To clean the brush properly, follow these steps:

2. Place the brush in a jar with turpentine.

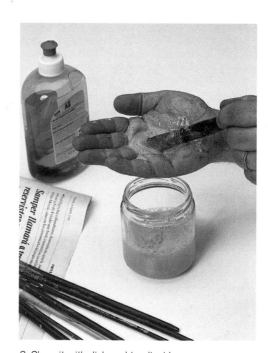

3. Clean it with dishwashing liquid.

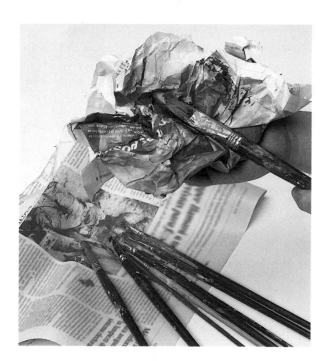

1. Clean the brush with newspaper.

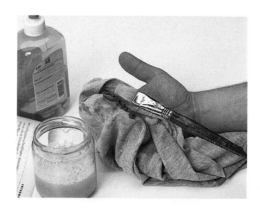

4. Dry it with a soft cloth.

Materials required

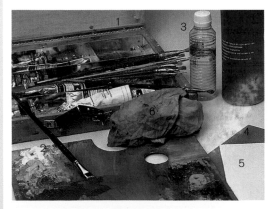

Oils (1), brush (2), turpentine (3), board to support canvas (4), canvas or canvas board (5), and cloth (6).

In order to control the oil medium you have to take chances and lose your fear of the blank canvas, even if your first tries don't measure up to your truest aim.

For this exercise, the theme of flowers has been chosen. In this case the final result doesn't have to show either great or small verisimilitude with the model. Carrying out the step-by-step procedure will allow us to practice different types of brushstrokes, which is the main reason for the picture.

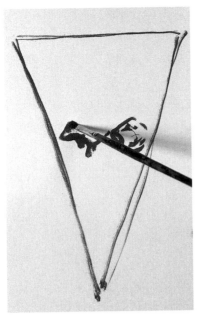

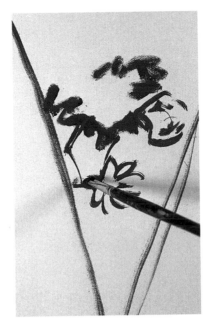

This exercise is begun in carmine. Draw an elongated triangular form to frame the flowers. Move your hand all the way to the end of the brush handle and draw in very loose brushstrokes inside the central area of the triangle.

Begin to draw a daisy and leave a few loose strokes in the upper part of the original triangle.

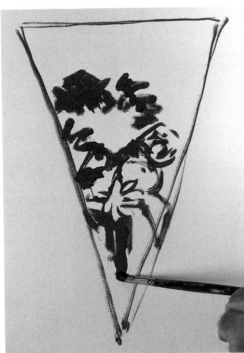

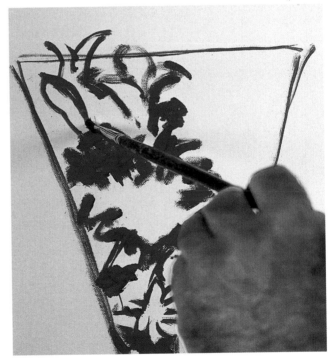

Before loading the brush with more paint, execute a few very loose strokes in the upper part of the triangle. Now load the brush. If the paint is too thick, use turpentine and thin the color on the palette. If the paint has liquefied, squeeze out the brush on the cloth to keep it from dripping onto the canvas.

In the lower part of the triangle, a few straight lines (see 2) should be brushed in. Use very loose brushstrokes on the left-hand side, as in the first step, holding the brush close to the ferrule so as to be able to control the lines with a simple movement of your fingers.

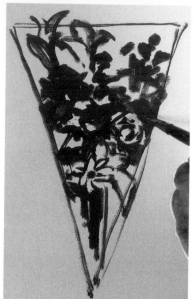

 4

Once you've practiced all the brush techniques shown in this chapter using only one color (so as not to lose the real intention of the design), we'll add some other colors like white, pink, green, dark blue, yellow, and another shade of red, as indicated in step 5.

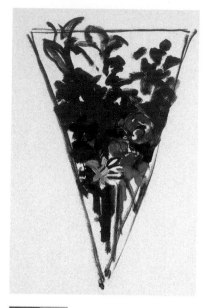

 5

Using a very small brushstroke, add some yellow to the center of the daisy. Beside this, add a patch of dark blue. The petals are painted with very short, precise strokes, just like what was practiced above. With a bit of green, add to the spaces between the flowers. It isn't important in this exercise if some of the adjacent color mixes together. Don't try to repair that if it happens.

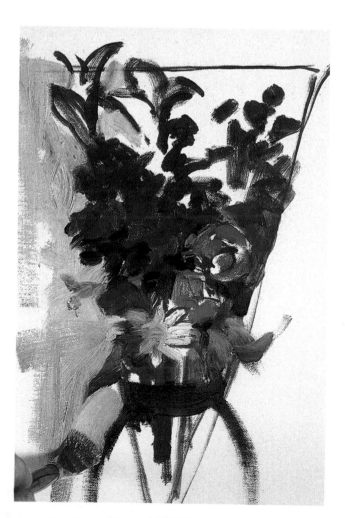

 6

With a little white and blue, begin to paint the background. The strokes should be long and vertical, and done several times so that the lines overlap and again mix partly with the color previously applied. When you get to the area where the flowers are painted, the brushstrokes should be short and precise. For this, use the brush as if it were a pencil.

The darkest colors on the palette can now be mixed together to obtain a deep tone. With this, draw two curved lines for the mouth of the jar and then two others that sketch its sides.

Use the brush as if it were a pencil.

The brush is almost dry here, but before loading more paint, put in a few very loose lines.

Hold the brush by the end.

Very short and precise strokes.

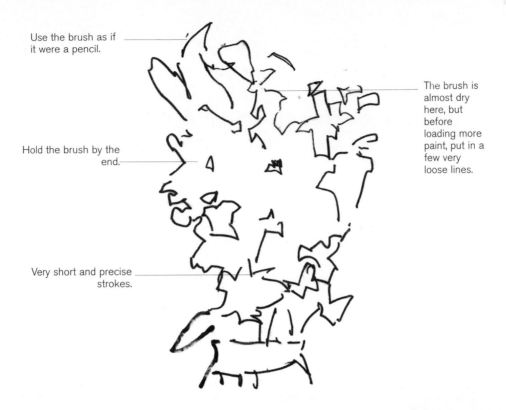

Simple forms for complex pictures

With the appearance of oil paint and its introduction from Flanders to Italy and Spain, painting acquired a much more realistic form of representation, as can be appreciated in the illustration.

The Immaculate Conception by Francisco de Zurbarán (1598-1664).

In this piece, which is in the Museu d'Art de Catalunya, in Barcelona, the colors, which are luminous, confer on the picture a very realistic character. The volume is perfectly defined and today has the same appearance as when it was originally painted.

2 Obtaining colors with oil paints

Oil painting is a pictorial procedure with enormous chromatic possibilities owing to its enormous richness of nuances and its great brightness. To dominate this medium, it is very useful to have an in-depth knowledge of color theory and of the color spectrum.

Applying color

Oil is a versatile medium that makes it possible to work with very opaque colors or with almost transparent values in relation to the amount of linseed oil and turpentine that one adds. The present unit will discuss light and shadow in oil painting and types of color mixtures.

A DENSE, OPAQUE MEDIUM

Oil colors are thick so that the paste that contains the color is sufficiently oily to create large layers of paint on the canvas. Because the paint dries slowly, it is possible to pick up a work session after a certain amount of time has passed without letting the color dry completely. This makes it possible to work with great tranquility. On the other hand, it is a medium that is opaque when it comes out of the tube but which can be thinned by adding linseed oil or turpentine.

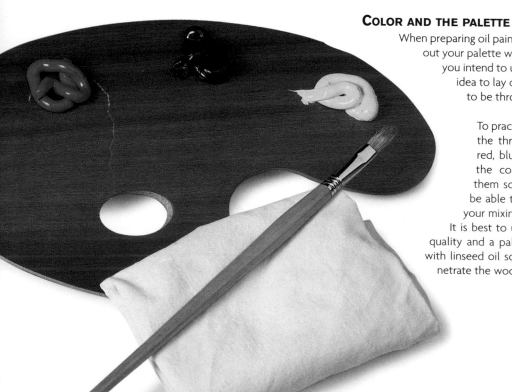

COLOR AND THE PALETTE

When preparing oil paint for painting, you should lay out your palette with only the amount of color you intend to use. It's obviously not a good idea to lay out paints that will only have to be thrown away later.

To practice mixing color, you'll need the three basic or primary colors: red, blue, and yellow. When laying the colors on the palette, keep them some distance apart so as to be able to have enough space to do your mixing with the palette knife.

It is best to use colors of an acceptable quality and a palette with a surface primed with linseed oil so that the color doesn't penetrate the wood fiber.

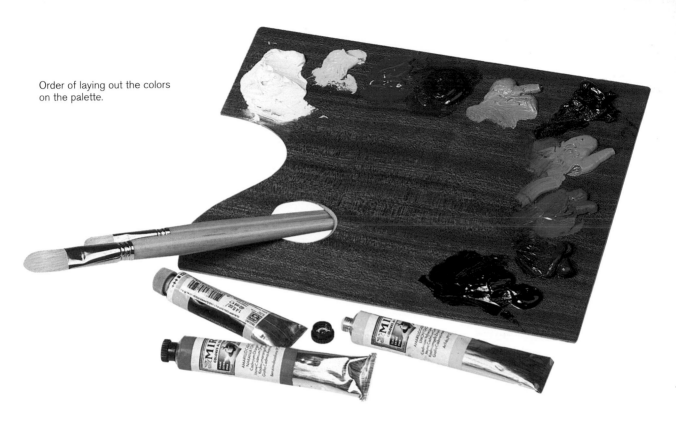

Order of laying out the colors on the palette.

LAYING OUT THE PAINTS ON THE PALETTE

When you paint with oil using a wider range of colors, these should be kept in a strict order on the palette to be able to use them easily. They should be laid out in the following way: first, on the left, white, always in abundant quantity; next, in ascending tonal and chromatic order, yellow, red, the earth colors (ochre and burnt sienna); finally, green, blue, indigo, and black.

HARMONIC OR CHROMATIC RANGES

The colors can be classified according to their tone and intensity, making up what is called the harmonic or chromatic ranges, which can be warm, cool, and neutral or tertiary. To do this, some knowledge of the theory of color is necessary. According to this the

Color formation

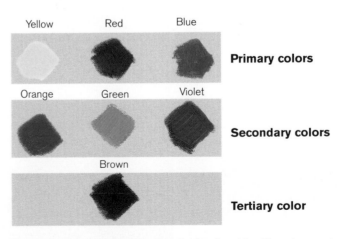

Yellow	Red	Blue	
			Primary colors
Orange	Green	Violet	
			Secondary colors
Brown			
			Tertiary color

The graph represents the formation of colors by mixing. The primary colors produce secondary colors when mixed. Mixing two or more secondary colors creates a neutral or tertiary color.

ory, as was indicated above, there are three basic or primary colors: yellow, blue, and red. When two primary colors are mixed together they create the secondary colors, which are orange, green, and violet. The neutral or tertiary colors come from mixing a secondary with a primary which was not used in its derivation.

THE WARM COLORS

The colors that make up the warm range extend from magenta to yellow and even the earth colors. So the warm co-

lors include: orange, red, carmine, ochre, sienna, burnt sienna, and burnt umber.

THE COOL COLORS

The cool colors are the blues and those that come from mixing blue with yellow and magenta. That is, the greens and the violets. So this range is composed of, among others, blue, green, violet, and purple.

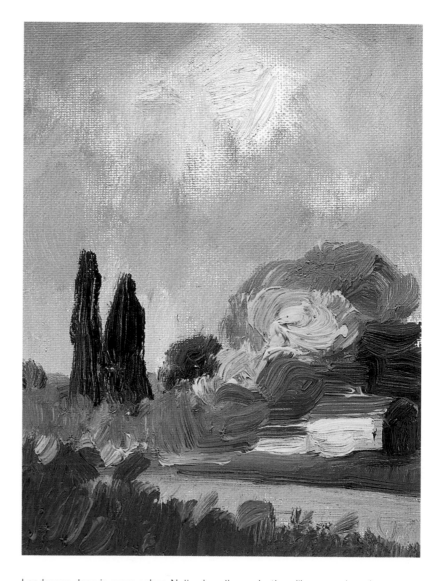

Sample of warm colors

Landscape done in warm colors. Notice how the cool colors, like green, have been mixed with red to create contrast.

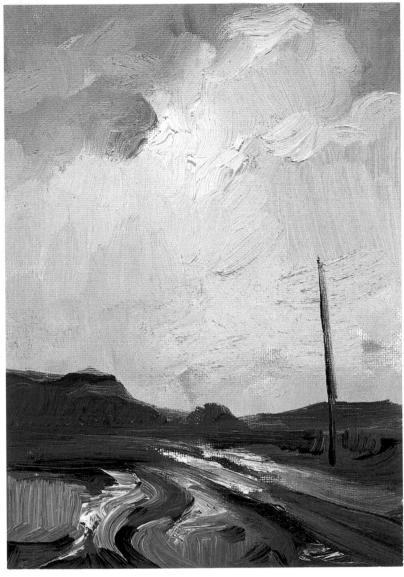

Landscape done in cool colors.

Sample of cool colors.

THE NEUTRAL COLORS

The neutral range is made up of colors toned with gray and browns. These are created from a mixture of two secondary colors or of one primary color with its opposite or complementary color. Although they are colors that stand out by way of their lack of vividness, when used harmoniously without mixing with warm or cool colors they can help create works of great distinction and beauty. While many pictures are painted with colors that belong to the three types (as long as an attempt is made in the work to maintain chromatic unity), their colors must make up part of a single range, warm, cool, or neutral.

INTENSIFYING AND TONING

Working with oil paints requires special attention when it comes to intensifying or toning a color because depending on the way this is done the picture will gain in force and contrast or else lose the brightness associated with this medium. In general, it's better not to use black and to mute your colors by mixing them with their complement, adding the darker color in small amounts.

Trying oil

To get to know the characteristics of oil paint there is no better method than using palette and brush, even if you only paint a simple form.

To paint a flower motif, first make some loose fan-shaped strokes with yellow. Then use green to draw the stem and add some blue at the base of the flower. You might want to paint some carmine lines over the yellow, dragging some of the yellow with the brushstroke (a clear example of how oily the medium is). Finally, use some green mixed with yellow on the stem, noting how the color's opacity makes it possible to paint light tones over dark ones.

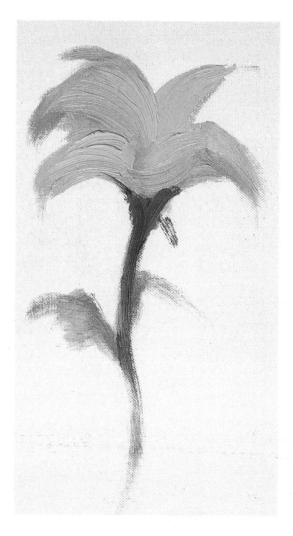 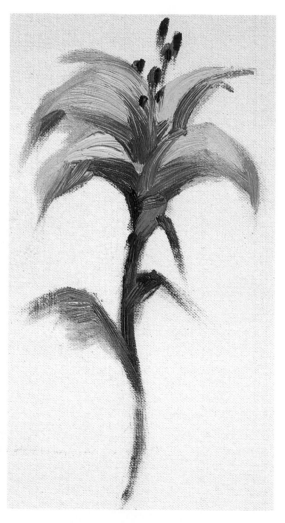

In the first brushstrokes the paint's oily pastiness can be appreciated. It is capable of bringing about great volume in the petals of the flower.

You can work with very flowing strokes over the previously applied colors. Note how the carmine has mixed some of the still-wet yellow with it.

BRIGHTENING (INTENSIFYING) A COLOR

When you want to make a color brighter, in spite of what may at first seem to be involved, you shouldn't use white, which will only decrease the vividness and brightness of the original color. White (almost never used in pure form) is mainly used to gray the hues or to cover specific areas.

DARKENING (TONING) A COLOR

In a similar way to white, black is an ill-advised choice for toning down a hue. It is true that black will cause the painting to become dark, but it will also deaden the color and take away from the overall vividness.

Note what happens when the landscapes on the right are darkened or lightened with black or white. Then observe the difference when colors lighter or darker than those originally laid are used.

When it comes to painting a picture, the artist must always bear in mind that exact colors identifying concrete objects don't exist, although unconsciously such a relationship is often made.

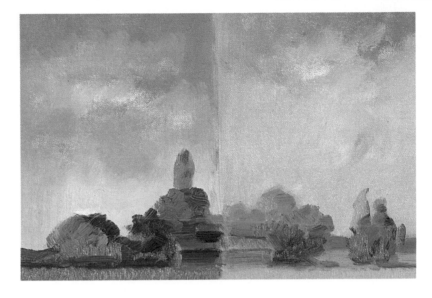

The left-hand side of the picture was intensified by using lighter tones than those originally laid; the right-hand side was intensified using white, which led to loss of brightness and glow.

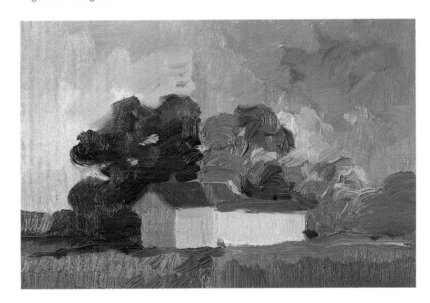

On the left, black was used to darken the picture. On the right, dark but vivid colors were used to tone down the picture, which thus gains in luminosity.

Objects do not possess intrinsic colors that identify them. This orange shows us bluish tones in its shadows, perhaps due to the existence of a bluish object beside it.

Basic colors
Landscape

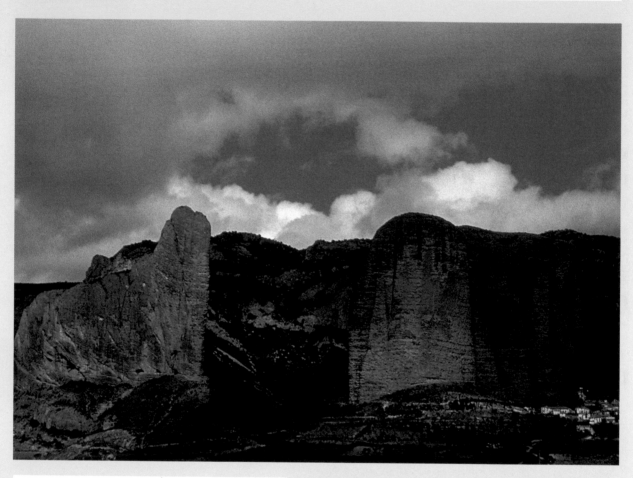

Materials required

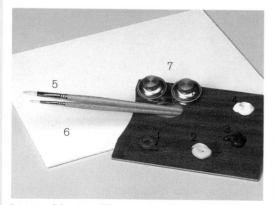

Oils: blue (1), yellow (2), magenta (3), and white (4), hog-bristle brushes (5), canvas board (6), linseed oil and turpentine (7).

Mixing colors is a practice every artist must carry out habitually to dominate color theory and its practical results. With only the three primary colors and white almost all the tones observed in nature can be obtained.

In what follows, an exercise is proposed involving the painting of some highly colorful cliffs using the basic colors and white. In the process of the initial roughing out, all the brushstrokes will seem to clash, but little by little each area will progressively take on form via its respective color.

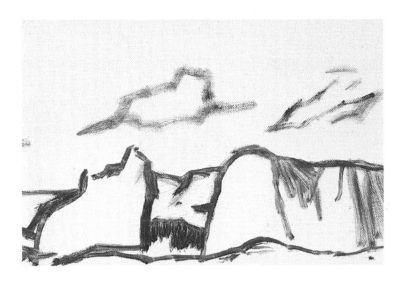

 1

The picture is begun by wetting the brush in turpentine and removing the excess on the edge of the deposit before laying on the blue color. Next, begin to draw on the canvas board. Paint the ground line and over this rough out the form of the cliffs. Finally, draw the outline of the clouds in the sky.

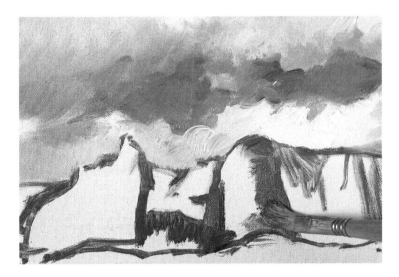

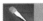 **2**

Load the brush with a little blue and add white until you have a much brighter and thicker cerulean than the color of the clouds (this mixture doesn't incorporate magenta). Paint the central blue zone of the sky. With almost pure white, paint the upper zone of the lowest clouds.

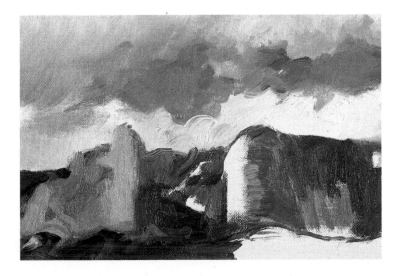

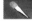 **3**

Paint the cliffs in varied colors, forming different mixtures on the palette: with yellow and blue, create a green (the brightness of which will vary according to the amount of blue—in this case, nearly 100%); with blue and magenta, create a violet; with yellow and magenta, create an orange.

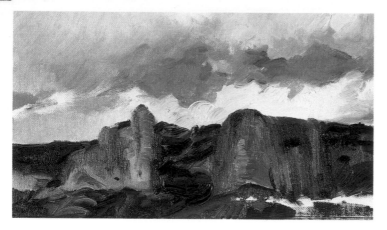

4

The contrasts of the rocky walls are painted with darker neutral values than the first colors laid.

The most luminous zone of the cliff is painted in a rosy color, made by using magenta and white, to which a bit of yellow is added.

5

Keep working with different green tones in the lower part of the picture. First get a green with yellow and blue, mixing it well on the palette. Then, with a bit of magenta, break up the color and make it earthier.

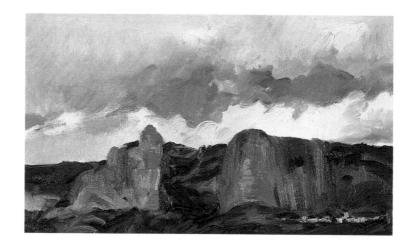

6

Finally, add the cliffs' contrasts using dark values. Also use these same dark tones to paint the setting around the little white houses to make the latter stand out even more.

This step concludes the simple landscape and the fairly exhaustive practice of mixing colors.

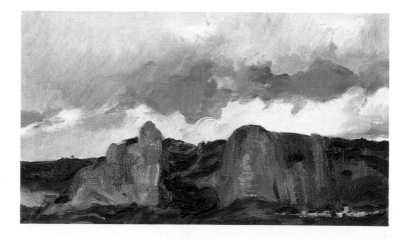

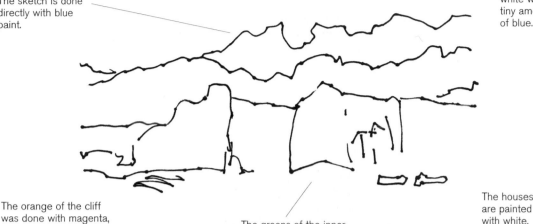

The sketch is done directly with blue paint.

The whitest aspect of the clouds is almost pure white with a tiny amount of blue.

The orange of the cliff was done with magenta, yellow, and some blue.

The greens of the inner zone came from mixing blue, yellow, and some magenta.

The houses are painted with white.

A bright and at the same time opaque medium

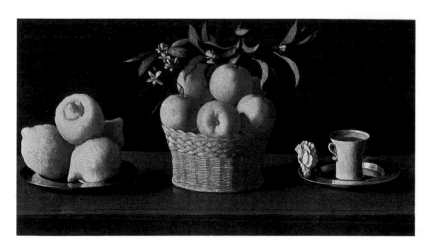

Oil paint has so many possibilities that it is considered as the most important pictorial procedure that exists.

Since the appearance of oil, the great artists have never ceased to be surprised by its mastery, creating works capable of combining opacity with transparency.

This still life with lemons, oranges, and a rose, the work of Francisco de Zurbarán (1598-1664) is part of the collection of count Contini-Bonacossi in Florence. The painting surprises by its contrast between the opacity of the table and the background and the enormous luminosity and transparency of the fruit and the other objects making it up.

3 Drawing in oil

Oil is not only a medium that offers an extremely wide range of colors but one which, because of its density, allows the artist to make sketches modeling form, conferring on the finished work a characteristic texture.

The medium

Oil is a paste-like medium. It is dense enough to permit thick, opaque lines. The painter will immediately appreciate how the texture is very like butter, with the difference that oil paint incorporates one incomparable quality: one of the widest ranges of colors that any pictorial medium can offer.

Oil painting thus provides a weighty enough substance to confer on the finished work that characteristic texture. Once dry, oil does not vary its form. This quality alone sums up the possibility of manipulation with the brush.

BRUSHSTROKES

Brushstrokes comprise a way of applying paint to the painting surface via the brush. Oil is highly malleable and can be modeled very well in its application. This makes it important to know how to dominate the stroke. The hand must become accustomed to the feel of the brush, something that is indispensable for the painter. With the practices outlined in the present chapter, you'll be able to try out the variations of oil according to different ways of applying the brush to the picture.

Oil color has a texture like butter so that it adheres to the brush as a malleable paste.

Holding the brush

Before beginning to try different strokes and lines, get comfortable with the different ways of holding the brush. Each one of these has a feel about it and a different sensation when applied to the canvas.

The closer to the ferrule you hold the brush, the more the wrist and fingers will come into play in the brushstroke. If you hold it close to the center or toward the end, the gesture will be dominated by forearm movement.

The method of closing your hand around the brush is equally important: turn up your palm and rest the handle on your fingers, then close your fingers around the handle. The brush is thud held a little closer to the ferrule and acts more like a natural prolongation of the arm. The pressure on the canvas will be different than when you hold the brush like a pencil (for detail work). Holding your hand around the handle, you can use more energetic motions of the whole arm, although the line drawn won't be as firm.

SKETCH LINES

The lines of your sketches are what determine a smooth, linear brushstroke. It will be similar to what is obtained using charcoal or other types of drawing media, but with the advantage that the line can be much more continuous. In general, this type of line is done once a pre-sketch in charcoal, pencil, or thin paint has been put down. To start with, wet the brush in turpentine and with a dark color (the tone isn't extremely important) and go over the lines of the pre-sketch, unifying the model being developed.

If the brush is overloaded, the fluidity of the brushstroke may slip on the canvas, so it's important to control the amount of paint you load. The brush shouldn't be too wide. For this phase of the picture, it is important to use a rather thin hog bristle brush. Why hog bristle? Very simple: hog bristle doesn't absorb a large amount of paint and therefore also won't become saturated with turpentine. It will give you better control of the line on the canvas.

FIRST BRUSHSTROKES

The first brushstrokes are those made on the prepared canvas. There is a basic principle that must always be respected: oil must be applied fat over lean or, what amounts to the same thing, the first strokes must always have more turpentine than the successive ones.

Turpentine makes oil much more fluid and transparent, so its application on the painting surface hardly allows the brush to leave its characteristic trace. These first layers of color offer the possibility of covering any area with great rapidity. While it's important to keep the paint from dripping, accidents can be repaired in successive layers.

Both the successive layers of brushstrokes on the tree and those of the grass are made up of series of straight lines.

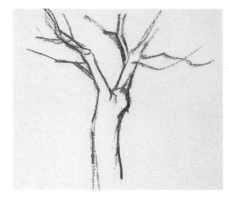

Onto the charcoal or pencil sketch, thinned paint is superimposed.

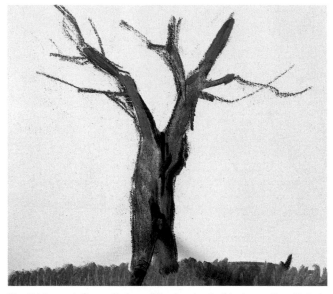

The thicker paint is applied over the drawing in thin, turpentine-diluted paint. This time, the brushstroke acquires the typical characteristics of the brush being used.

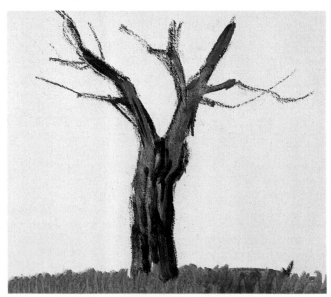

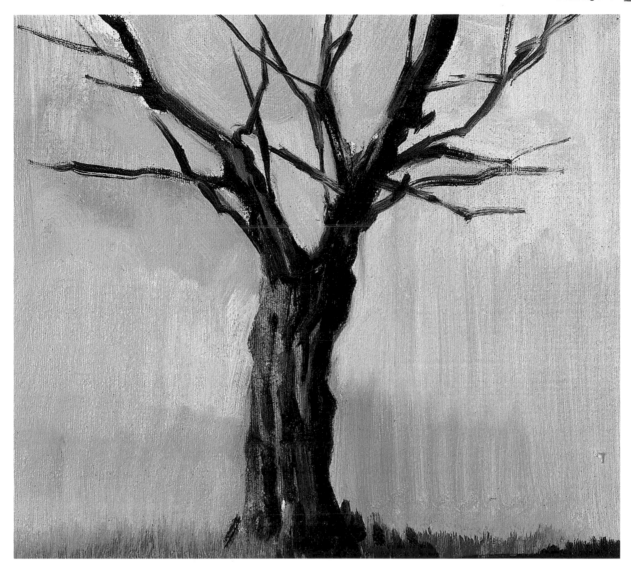

The background of the picture is painted using straight vertical strokes which join together to form an extensive blue mass. Over this, the tree is completed with straight lines that configure the trunk and branches.

STRAIGHT BRUSHSTROKES

The first brushstrokes applied to a sketch on the toned ground must be very ordered, more than anything to avoid a chaos of lines that would lead to confusion.

This order in the manner of applying the brushstrokes must be respected at least in the first practice pieces, until one gets used to applying color.

BACKGROUND PAINTING

One thin line beside another obviously forms a thicker mark, and with this idea the entire background of the painting is effected. Using blue in thin brushstrokes fills the entire background. Onto this large mass of color the form of the tree is completed and, finally, in darker tones, the details of the branches. The brushstrokes become large areas of paint when grouped together. The marks do not have to use great quantities of paint.

DIFFERENT TYPES OF LINE FOR EACH AREA

The foregoing techniques have shown how it is possible to study the way the main oil painting processes can be studied successively. First, the brush technique used in sketching and roughing out figures; over this, the turpentine-thinned ground; then, finally, the finish.

The order of these phases is important but at times it's convenient to have each area of the painting in a different phase.

FIRST GROUNDS

As a general rule, the first step in painting in oil consists in applying a thinned color that forms a ground on the maximum possible surface area of the canvas and that gives rise to a sufficiently solid base of color on which to lay heavier patches of paint.

While these patches will always be started with pencil or charcoal indications, alternatives are possible since, often, according to the complexity of the subject, a sketch will be made directly in oil (although always thinned with turpentine).

CONTRASTS AND HEAVY STROKES

Over the perfectly constructed ground heavier brushstrokes can be progressively laid. A much heavier line will be used, laying the colors over the first coat.

As is only logical, in applying color part of the lower coat will be dragged along if it is still fresh. Bear in mind that thinned layers dry much more quickly that thick impasto.
Although thicker layers are used, it is not usually good to use pure paint as it comes out of the tube. At present, suffice it to say that it should be slightly thinned with turpentine, though not nearly so much as for the priming.

The contrasts in those rocky cliffs are done by means of sets of straight lines that vary in direction according to the plane they occupy. Water is painted with a very different line from that used for rocks, a line where horizontality predominates and the brushstrokes don't cross over each other.
The treatment of the sky depends on the form of the clouds, which are painted in white with curved lines.

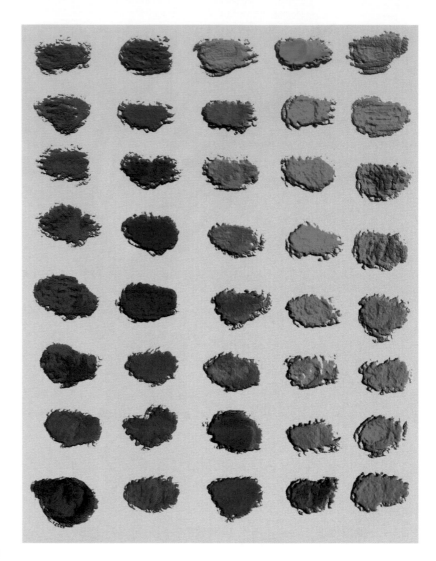

The range of colors is one of the most important questions in beginning to paint. Making a color code like the one shown here is not a complex task and it will greatly aid your understanding of how colors are combined to create different values. To build a range like this, start with yellow and add a little green, progressively adding more of the darker color. Then, the blue range is planned, mixing with darker tones. Finally, do the violets, starting with blue and adding carmine in the same progressive way.

PURE COLORS (HUES) ACONTROLLED LINES

The brushstroke becomes heavier as the picture advances. Each time it will be less necessary to mix paint with turpentine, and the line will be more obvious due to the thickness of the paint. The lower, fresh layers make it possible for these later ones to include brushwork where the new line lightly merges with the color of the picture, so that the colors integrate together perfectly.

In this type of fresh, spontaneous piece it isn't necessary to go over the brushwork very much. It is usually sufficient to use one line per stroke be-

Types of brushstrokes

When long straight lines are used, the color gives out and the brushstroke appears thinner.

There is a type of technique called impasto which is characterized by its use of a short stroke executed with some pressure.

When doing loose lines, the direction of the stroke comes from twisting the wrist and flexing the fingers.

These first rough sketches were made with charcoal and/or pencil. However, later on they'll be done with a thinned neutral color.

cause the colors will fuse if you go back over them, as we shall see below.

THE FINISH

The finish requires a fresh approach. To get this, remember that you must know when to stop: it simply isn't necessary to insist at every point on the canvas. There will be parts you'll want to leave just as they were when you started and other newer ones that will have been reworked into thick impasto.

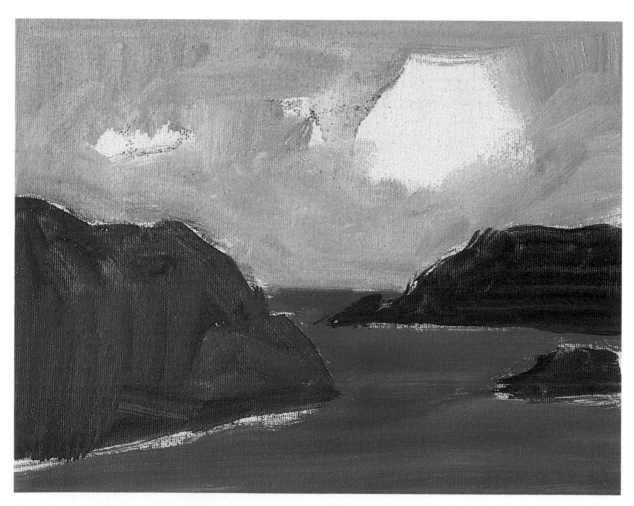

Each of the areas of the painting is solved via different treatment of line and brushstroke.

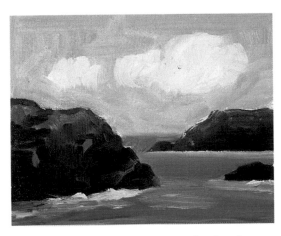

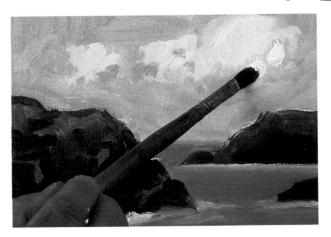

The contrasts are applied with a heavier line than the one used in the first layers.

The contrasts are applied with a heavier line than the one used in the first layers.

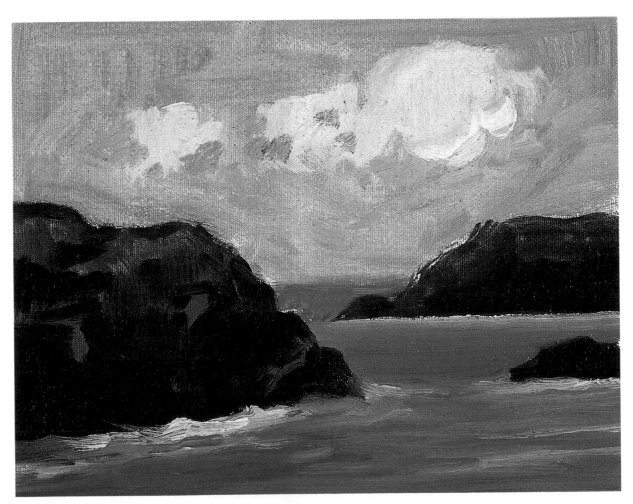

You have to know when to finish the piece—a question of practice.

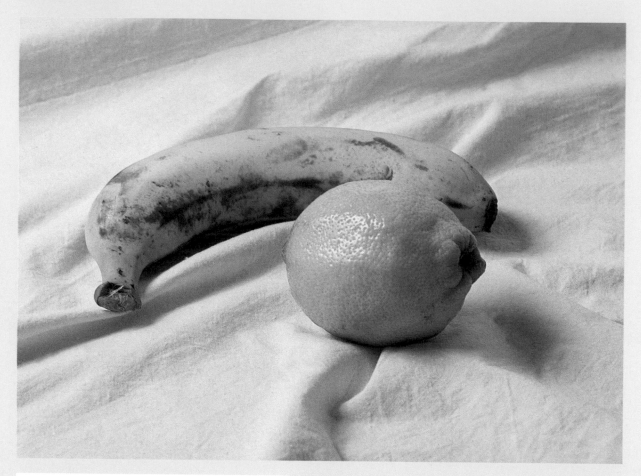

Materials required

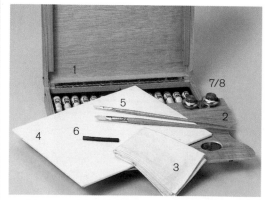

Oils (1), palette (2), cloth (3), canvas board (4), brushes (5), charcoal (6), linseed oil (7), and turpentine (8).

The proposal here is to do a simple still life of two pieces of fruit, a banana and a lemon.

The exercise is not very difficult since the range of colors chosen is restricted: it is based on variations of yellow, green, and sienna. As to the composition and the drawing, these also are easy to resolve, although as has been stated before, it is important to pay attention to this first phase of painting the picture.

The initial sketch for the picture is done in charcoal. This makes quick correction possible throughout this phase by simply passing your hand or a cloth over the lines you want to erase.

It's important to work from a well-constructed drawing since the better planned the initial steps the fewer corrections will be needed later.

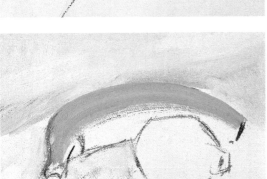

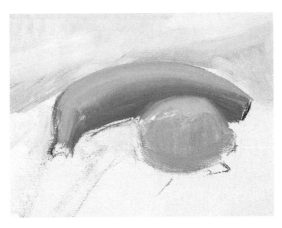

Begin with thin color, using the palette knife to mix it on the palette with turpentine to get the proper consistency. Also begin to paint in the background with a thin, much lightened blue. In this area the brushstrokes should be much longer, and they should blend into each other.

The banana is painted in yellow. This should be grayed down in the darker areas, by adding just a tiny amount of sienna, just barely enough to slightly tone the original color, using the palette knife to mix it. Where the darker tone meets the lighter they should fuse, but the feel of the line should be maintained. Paint the lemon in a very light yellow.

Paint all of the background of the piece so that the effect of the contrasts in the values of the two objects and the space around them can be appreciated. The dark areas of the folds should be painted in very light blue, with a touch of yellow. The line of the shadows will be vertical in some areas and will follow the folds in others; the line of the highlighted parts is completely white and elongated.

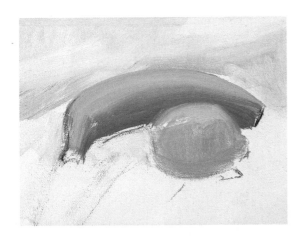

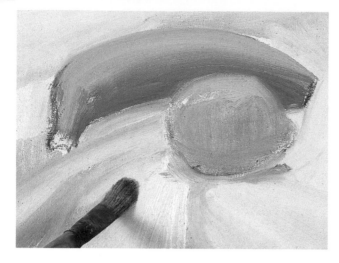

 5

The foreground of the canvas should be painted with long strokes in the direction of the central theme of the composition, an area where contrasts increase. In the remaining areas, the light tones may be equal.

Paint the shadows of the two pieces of fruit with an adequate brush treatment.

In the banana, the brushstroke will always be elongated; in the lemon, shorten the stroke and seek the natural curve.

 6

The lemon can be worked out with fast direct strokes that follow the natural curve. Yellow imposes itself on the greenish shadow zone.

With the same blue hues of the background, added to yellow on the palette and mixed with the knife, a new color is created for the shadows. In the banana, this process should be followed using burnt sienna.

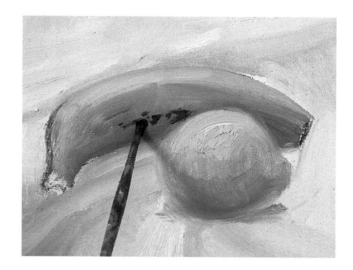

 7

The brushstroke will progressively become more closed, but try not to use an impasto any more than necessary. If there is too much paint, remove it with the clean brush and press it against the palette to deposit the excess color.

The profile of the forms is achieved with small contrasts added to the sketch.

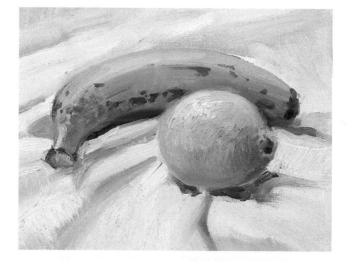

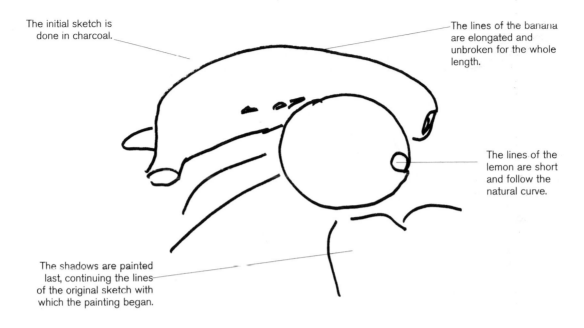

The initial sketch is done in charcoal.

The lines of the banana are elongated and unbroken for the whole length.

The lines of the lemon are short and follow the natural curve.

The shadows are painted last, continuing the lines of the original sketch with which the painting began.

A master of the line

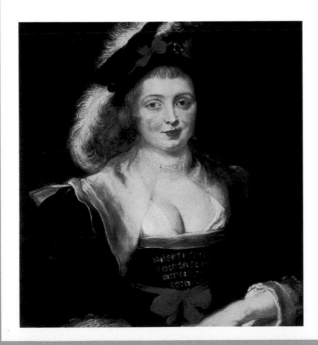

Rubens (1557-1640) was one of the great painting masters of history. His draftsmanship, present in all his works, is clear from the vigorous brushstrokes, even when the piece is totally finished. In this superb portrait—Helena Fourment, in the Grande Pinacoteque de Monaco—the line defining the forms can be appreciated in every part of the figure. Notice how the color of the line pulls some of the color adjacent to it. This is especially notable in the figure's left hand.

4 Using different brushstrokes

When painting in oil, some zones of the picture will require a brushstroke that lets the colors fuse together while in other zones the blending will be less marked.

Painting in oil

In applying oil paint, as we have seen, the first layers are laid with greater amounts of turpentine, which progressively diminishes as the work is completed.

From this unit on, we will not only use less turpentine, we will begin to incorporate linseed oil as the usual medium for liquefy the later layers.

FAT OVER LEAN

In the first trials and studies done in oil turpentine was used as a solvent for the primer coats. Linseed oil appeared only as the name of a material but wasn't used.

The reason for this "omission" is simple but calculated. We wished to familiarize ourselves with the possibility of liquefaction of oil paints, above all in the first layers of the painting (the stain or priming coat and the sketch) while laying on the succeeding ones much more directly.

But it may sometime be necessary to use a more fluid brush in layers that don't require turpentine.

In these cases, linseed oil is used as solvent or, if not, a balance between the two elements when the piece is halfway between hues thinned with turpentine and oilier ones.

Turpentine and linseed oil and the recipients used to hold them and which can be placed on the edge of the palette. From now on both substances will be used.

Procedure for thinning color and making it oily

Linseed oil makes it possible to continue the painting with more fluid colors which would otherwise have to be laid on as impasto.

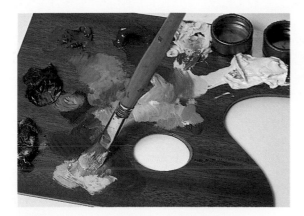

The recipients for linseed oil and turpentine can be placed on the edge of the palette, held by the clip on the bottom.

To thin any color with turpentine, simply wet the brush in it and apply it to the color on the palette until you get the consistency you need.

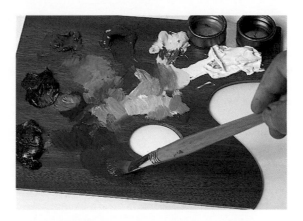

After dipping the brush into linseed oil, mix it with the color for greater fluidity and transparency as your later layers require (once the turpentine-thinned primers have been applied).

PROGRESSIVE THINNING

The new ideas offered in the units that follow will allow us to evolve a given technique and to test different possibilities.

In the present unit, we return to thinning with turpentine but with the added advantage that at some point in the process linseed oil will be substituted for turpentine or pure paint.

DOING WITHOUT CHARCOAL

The line obtained with the well-squeezed brush when thinned paint is used is much like that in habitual drawing procedures. Therefore, according to the subject you choose to paint, you may wish to avoid pencil or charcoal as, for example, in a landscape.

In the exercise that follows, no charcoal or pencil was used. A fine hog bristle brush dipped in turpentine with

a small amount of neutral color was used to draw with. To avoid excessive stain on the canvas, squeeze some of the turpentine and/or thinned paint out of the brush by pressing it against a cloth. With the brush squeezed out, you can do your sketching. The lines can be corrected and re-drawn as often as necessary.

If you wish to erase any area completely, rub it with a cloth moistened in

39

turpentine. In that case, however, be careful that it does not soak into the canvas.

PRIMING THE CANVAS WITH THINNED PAINT

Use turpentine-thinned paint to sketch onto the prepared canvas. The hues thinned in this way should not be so liquid that they slip across the surface. To thin a color it is not necessary to make it fully liquid or to prepare a large amount of it. The best system is to add turpentine to the color as you need it.

Thinned colors aren't as shiny when dry. It isn't necessary to use bright tones such as cadmiums, for example, which are expensive. Using these to stain the canvas would be wasteful. The best choice is simple neutral colors for the stain. Once this is done, you don't need to thin the colors as much and you can use better quality.

APPLYING THICK BRUSHSTROKES

The process of thinning must be calculated sufficiently so that it is never necessary to apply a thinned color over paint that comes directly out of the tube.

As the successive layers are added, the amount of turpentine should decrease until you are ready to apply paint right out of the tube. It is not necessary to begin with pure layers of impasto since, obviously, this would be breaking the "fat over lean" rule.

If a transparent layer is desired immediately after the thinned priming coat, mix linseed oil and turpentine. To do this, load a brush with each product, place it on the palette, and add color, using the same brush.

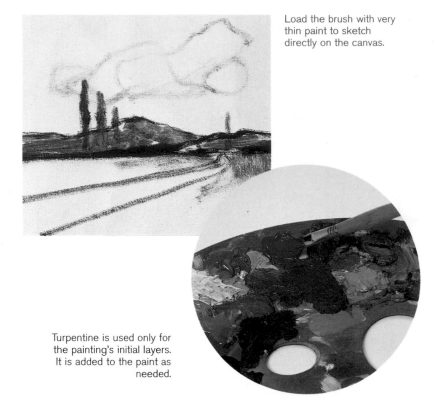

Load the brush with very thin paint to sketch directly on the canvas.

Turpentine is used only for the painting's initial layers. It is added to the paint as needed.

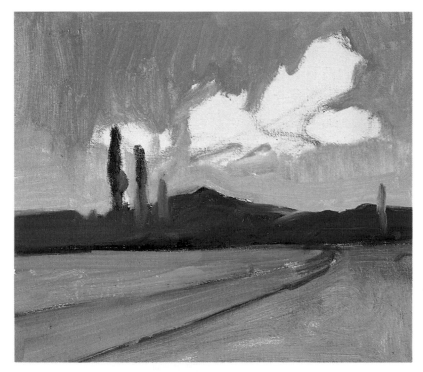

The first thin layers are painted onto the sketch. Even in small amounts turpentine causes the hues to lose brightness, which will, of course, increase when the paint is applied without the thinner.

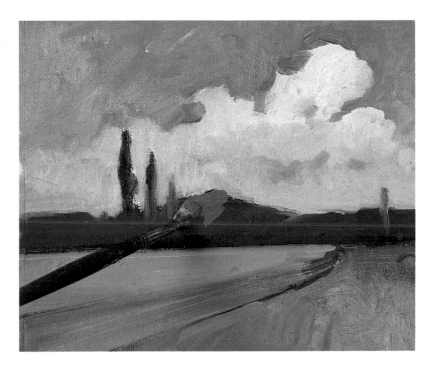

The layers succeeding the thinned stain are in increasingly pure and thus bright hues. A layer of pure paint should be applied prior to adding linseed oil to the next ones.

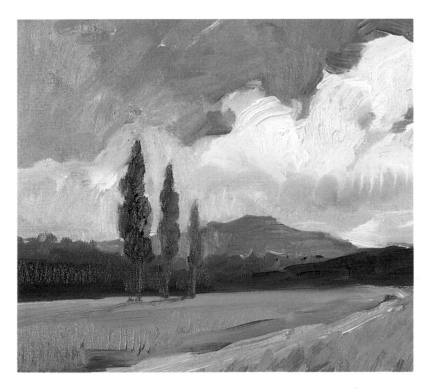

Detailed strokes are the last to go in (once the picture has been completed).

BRUSHSTROKE BESIDE BRUSHSTROKE

The picture will give rise to a more exhaustive treatment of brushstrokes. The underpainting becomes progressively concrete until the details are finally put in over the general areas of the picture.

When you reach this point, if you've followed the procedure explained above, your brushstrokes can be much closer to impasto than previous ones. And the colors in this layer will be applied just as they come out of the tube and therefore be highly luminous. The final brushstrokes applied in this landscape are those used for the grass in the foreground and the bright yellows in the clouds.

There is another important question appreciable in this simple example of landscape: if you observe the background you'll note that the shadows have been put in last. This is part of the correct form of painting in oil. The dark colors, above all blacks, should not be painted under brighter colors. The difference in drying between the layers makes cracks appear.

FAST STROKES

Proceeding from priming to painting the picture can be very elaborate or else very fast and spontaneous. Going slowly with the actual painting doesn't necessarily mean a better picture. Often, the only thing one achieves is ruining it.

As we've seen, the process of painting a picture includes a series of steps, among them the important phase of the priming with thinned paint, the sketch, and, later, the detail work.

The combination of the different processes may give rise to an immediate composition where simple but highly interesting techniques are played off one another.

In the last unit, a tree trunk was among the forms studied. We now propose a similar exercise but the interest in its creation is totally different. It is of interest above all to use to advantage the early layers to make the background breath through the brushstrokes.

THE TONED GROUND AND THE UNDERPAINTING

Over the primed canvas, a toned ground is applied. This may be done in different ways. It doesn't matter greatly how much turpentine is used in the ground or stain, and it can be applied by scumbling with a nearly dry brush, or by manipulating the moistness of the turpentine and thus bestowing a determined texture to the ground.

The picture thus acquires different plastic values (i.e., expressive capacity of a layer such as the stain, the sketch, the underpainting, or any other effect in the process).

To paint the tree proposed here, use thinned paint but not in a single uniform layer. Instead, paint in different intensities, alternating the transparency of the thinned coat with layers of paint containing less turpentine and that contrast in brightness with the early layers.

COVER THE WHOLE SURFACE

As in our previous exercises, as the process advances, the paint will be closer to impasto—dark and dense. Use dark strokes on the sides of the canvas and brighter ones in the other areas, letting the thinned primed layer breathe through the whole.
As you continue to stain the canvas, it is important to cover the whole surface. In this way the real contrasts will be appreciated among the main figures and the background. While the background may be in light colors, it is fundamental to paint it, since the result of the contrast will be very different from the completely white priming you started with.

DETAILED BRUSHSTROKES AND VARNISH

Even the fastest executed pieces require a well-organized process. The series of layers grows increasingly concrete and ends by the use of very highly detailed strokes carefully laid on areas you want to emphasize.

Use burnt umber to finish the branches of the darkest parts. The lines can be loose but perfectly defined. Here, the brushwork is not in thinned hues but something closer to impasto, just as we've studied throughout this unit. To conclude this exercise, apply different intensities of greens that mix with some of the darker brushstrokes.

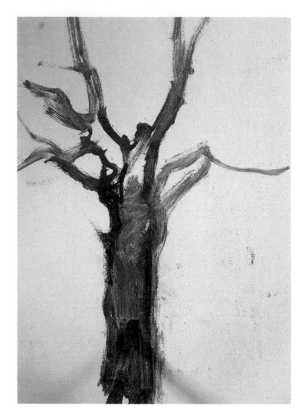

After laying out the main lines of the tree, paint the interior using different color values. Some of the brushwork can be completely transparent and some not so transparent. Colors to use: sienna, sepia, burnt umber.

As can be seen in the final version of this proposal, some of the layers originally painted in thinned hues have been left exactly the same in the lower part of the trunk.

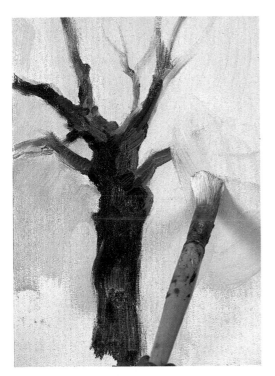

Until the entire surface of the canvas has been covered, the true contrasts among the tones used can't be appreciated.

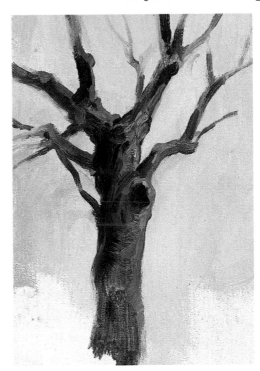

While dark colors have been applied to complete and define the tree, the thinned paint of the underpainting breathes through in the lower trunk.

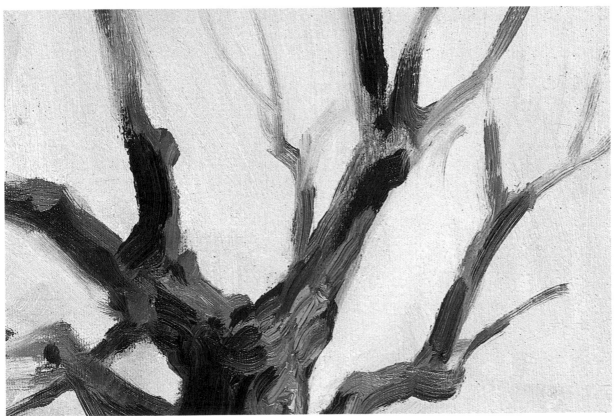

In this detail, you can see the brushwork in the now finished branches of the tree.

Lines
River landscape

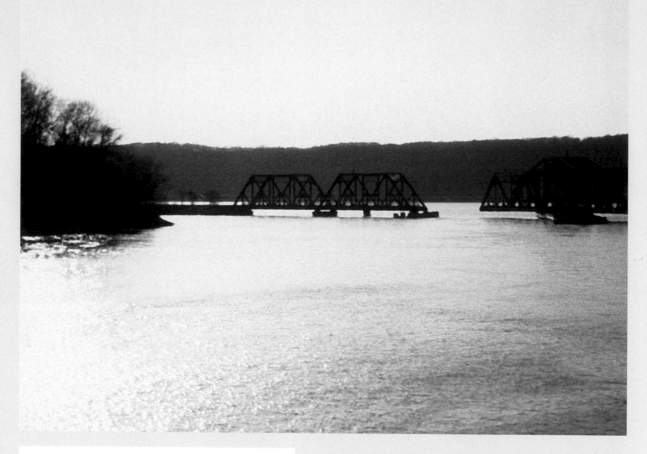

Materials required

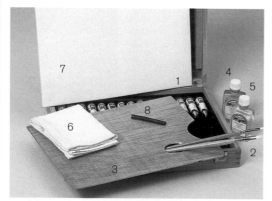

Oils (1), brushes (2), palette (3), linseed oil (4), turpentine (5), cloth (6), canvas board (7), charcoal (8).

The project for this unit is a river landscape. The model is simple, so much so that for the beginner it should present no great difficulty in terms of drawing and layout. The selection of this simple model will make it possible to study the process of oil technique in greater depth, from the creation of the initial sketch to the painting of the final details.

From the underpainting to the detailed brushstrokes or, what amounts to the same thing, from the general to the particular: this basic concept will be the cornerstone of our future work in oil. Hence, it is a good idea to pay attention to the treatment of the sketch and to the use of more or less thinned paint in the different layers.

On this occasion we'll use charcoal to place the horizon line and mountains in the upper third of the picture. Use the flat side of the charcoal on your toned ground to get a good straight line. The mountains can be lightly drawn in with the tip.

Once you've drawn in these simple forms, sketch the bridge and the woods on the left.

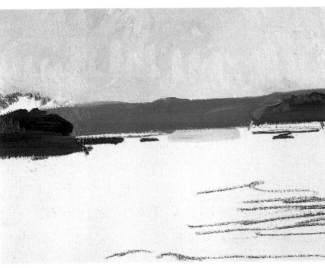

With very thin paint (but not so liquid that it drips), do the underpainting of the mountains in the background. Use a darker color that isn't as thin as the one used for the ground to sketch the mass of vegetation on the left and the dark mass on the right.

Notice that this layer is being superimposed on the thinned blue mountain line. The whole zone of sky at the top should be painted in a white tone.

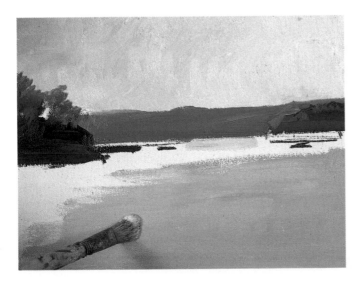
The vegetation contrasts with ultramarine and cobalt blue tones. In this area of the canvas, the strokes drag part of the white in the top third of the painting.

Begin to paint the water with an intensified blue. This will be the part of the landscape where the most changes will be made and thus where the greatest number of layers will be used. The first layer, which should cover all of this zone, is done with highly thinned paint, mixing different tones of blue, green, and white. The brushstrokes should be long and horizontal.

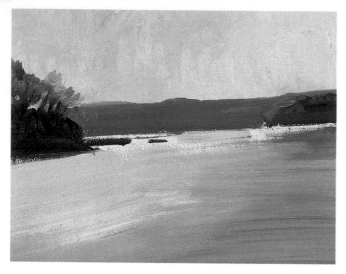

Go back to the path along of the river, where the trees are continued with more exact and detailed strokes than the previous ones. The tone blended previously will now serve as ground for these new brushstrokes.

This time paint over the water using a much thicker white color. Begin in the upper part and continue until you come to the lower blue area. Lay darker tones on that blue, this time closer to an impasto. The strokes blend over the ground with insistent passes.

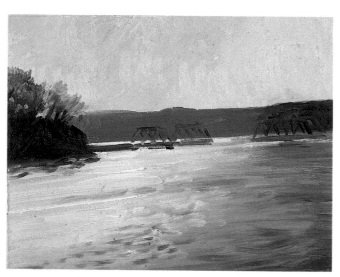

The underpainting is now complete. From now on, the color mixes and the different additions made to it will not use turpentine but be painted with paint as thick as it is right out of the tube.

In the darkest area, use dark blue. The strokes should not be the same but varied, some short, some longer. Blend the strokes with the tones of the underpainting. If the color is too thick, add a little linseed oil, but only a minimal amount.

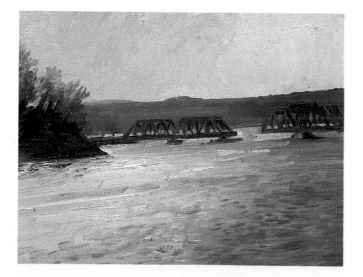

The detail work now centers on the trees, with very tiny strokes that mix with the background. Don't insist too much or the sketch line will disappear. The bridges are completed with dark, very straight strokes superimposed over the previous layers.

Finally, paint an impasto white on the brightest areas of the water. The last step will be to paint a series of very detailed highlights that contrast with the blue lines of the reflections.

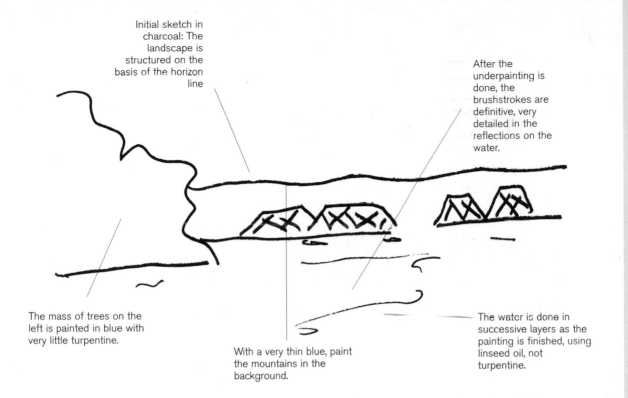

Initial sketch in charcoal: The landscape is structured on the basis of the horizon line

After the underpainting is done, the brushstrokes are definitive, very detailed in the reflections on the water.

The mass of trees on the left is painted in blue with very little turpentine.

With a very thin blue, paint the mountains in the background.

The water is done in successive layers as the painting is finished, using linseed oil, not turpentine.

Each brush in its place

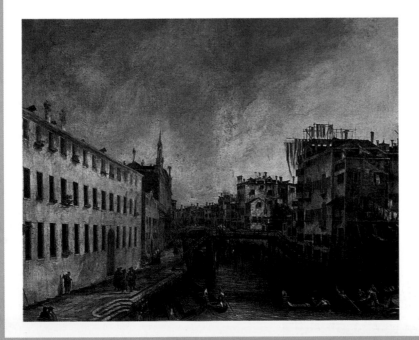

In this oil painting, Rio dei Mendicanti, by Antonio Canaletto (1697-1768) and in the Mario Crespi collection (Milan), we may appreciate the way the Venetian artist applied brushstrokes that are different for each area, according to the texture and the detail. The sky is painted with a great variety of tones but there is hardly any definition between the brushstrokes. Canaletto might perfectly well have used a thick brush and insistent blending over the tones to achieve perfect fusion. Instead, in the architecture, which is full of contrasts, he used with great confidence a fine brush for the lines and the exhaustive detail of the ornamentation.

5 Cool colors

With a determined range, such as the range of cool colors, it is possible to easily develop the tone of the colors without the problem of their growing muddy. You have to develop the security of creating results that are in complete harmony. In this unit, we will limit our palette to the cool colors.

Working with cool colors

Once you've learned how to mix color on the palette and acquired some understanding of the results of mixing the different colors, you should of course begin to paint with the results. Choosing a determined chromatic range allows you to center your attention on the fact of painting without having color overly condition your learning. Brushstrokes and gesture are two of the main resources among those valued by the painter in creating the picture. In this unit, we will study the toned ground (stain) of the painting, brushstrokes, and the use of color in the cool range.

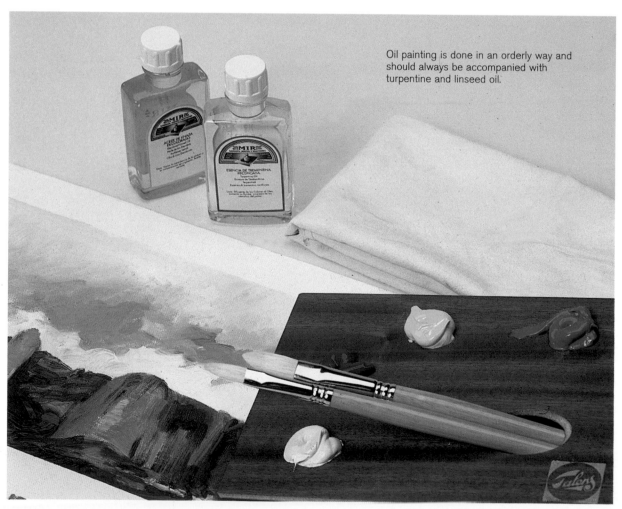

Oil painting is done in an orderly way and should always be accompanied with turpentine and linseed oil.

A progressive process

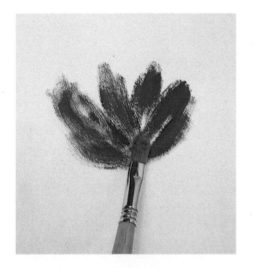

Thinned color should be used in the first layer of painting.

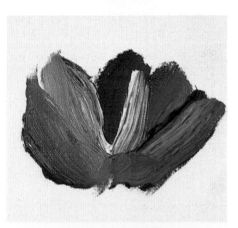

After the first strokes have been laid, you can make the form more detailed and approximate the color with thicker loads of paint, although turpentine is still used.

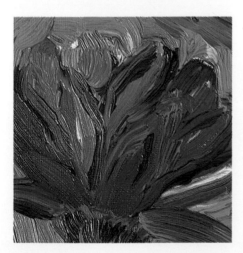

After the layers put on in the previous step, define the form with new strokes and apply more definitive color values.

THE DRYING PROCESS

Before continuing to learn about oil painting, it is a good idea to know about the drying process. In this way, it will be easier to learn the correct procedure in painting.

Oil paint dries extremely slowly. Unlike other (water base) pictorial media like watercolor, tempera, or acrylic, oil does not dry by evaporation since it has no water in it. Instead, the drying process is produced by oxidation of the surface in contact with the air.

The thickest layers thus dry first on the surface exposed to air and, little by little, the on the inside. The thinnest layers dry almost at the same rate inside and outside.

FAT OVER LEAN

The old saying in painting is "Fat over lean," that is, the first brushstrokes of the painting should incorporate a greater proportion of turpentine. This is done on the palette. First, dip the brush into the turpentine. Next, draw it across the blob of paint on the palette and deposit the load around the center of the palette. Mix the paint right there until it is homogenous. The result will be a thinned color that can be used directly on the canvas after the excess has been squeezed out of the brush (to avoid dripping).

The brush can be squeezed on the palette or on a cloth. The idea behind the toned ground applied with the thinned color is to establish the tone of the painting. Similarly, the underpainting sketched in thinned oil paint doesn't have to be a full definition of the forms but only to approximate the desired picture.

Often, painting with oil doesn't require sketching with charcoal. You can draw right on the ground with very thinned color and, over this, begin to paint in thicker, much less thinned layers.

THICKER LAYERS

After the first layers have been laid on, loosely and using very thin paint, you can apply thicker colors and begin to establish the definitive form. The order of the brushwork on an oil painting should always be progressive: the first steps don't need much detail. And in a similar way to the underpainting, the colors applied in the next steps need not be wholly definitive. Remember that oil can always be retouched; hence, it is always safer to progress step by step, not only in form but in color as well.

DETAILED BRUSHSTROKES

Form is easier to achieve after the underpainting and the first use of color. Over oil colors you can apply both light and dark hues. As we've already seen, oil is a dense, opaque medium. As the form grows to completion, greater detail can be added in definite strokes using tones that define the desired contrasts.

THE DIRECTION OF THE BRUSH-STROKE

Given the thick quality of oil, the brushstroke can be dense and malleable. The brush always leaves the trace of its hairs or bristles on the surface of the painting and this makes it possible, according to the pressure applied and the load of paint in the brush, to paint and simultaneously form the figure you are painting.

In the original priming and the toned ground the direction of the brush marks is not so important since the paint is thinned and the color is worked superficially. However, once the underdrawing has been laid on and you wish to begin painting the picture the more impasto strokes will mold the figure of the object represented. For example, if you wish to paint a simple flower, first dip the brush in thinned paint and sketch the form.

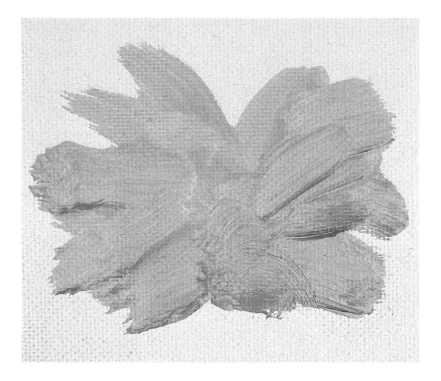

After painting the form it is important to control the brushstrokes.

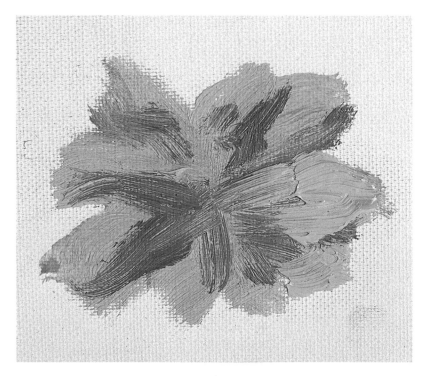

Free, loose brushstrokes define each plane—or facet—in a single movement. Over these, paint in green. Repeated strokes cause the colors to fuse.

Once this has been laid out, you can begin to paint with denser color, less thinned with turpentine. The brush-stroke will now begin to acquire a greater importance: each stroke marks a petal and, at the same time, superimposes traces of the hairs or bristles of the brush.

THE UNDERPAINTING AND COLOR

To correctly paint forms it is funda-mental for the underpainting also to follow a well-structured process. The area where the sketch is painted can anticipate the definitive form but without adding detail.

The final strokes establish the flower's definitive form. Finally, the background is finished in very loose impasto strokes.

A progressive task

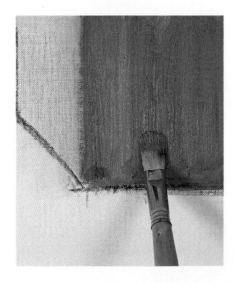

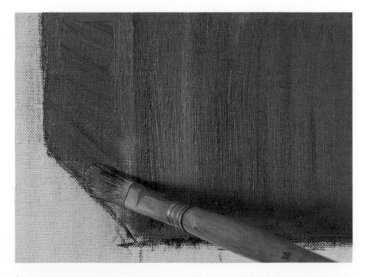

Each plane is colored in strokes in a determined direction, according to whether it is inclined or frontal.

Besides the direction of the brushstroke on the plane, it is important to bear in mind the colors used.

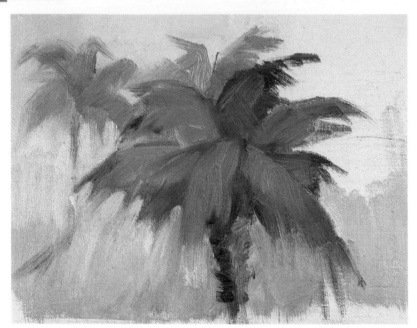

The initial sketch on the toned ground of the canvas generated strokes for both background and palm leaves. The latter were painted in strokes that drew part of the color into the background.

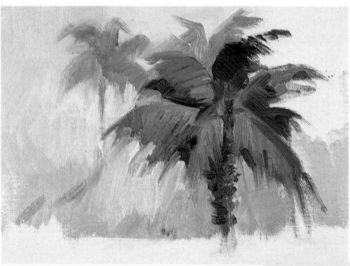

The superimposition of tiny strokes alternate with tones in the same range.

LINES AND TONES

As work advances, apply other tones over the initial one.

The new lines should follow the direction of the first strokes, in the process superimposing a new color value. The layer underneath is painted over with a new color and if the brush is repeatedly passed over that underlayer the colors may fuse.

As to line, as the painting progresses, the line configures what is being painted, each line defining a new facet. The background is painted in free, loose strokes when it is no longer necessary for them to define a concrete form. The tone chosen for these free background strokes can contrast with the main colors of the picture.

SUPERIMPOSING BRUSH-STROKES AND HUES

With oil it is possible to begin to paint the picture simultaneously on the whole surface and not limit yourself to painting the finished product zone by zone. If the background is painted at the same time as the rest of the main subject of the picture, the whole can be given formal details. For example, you can paint a main motif with free strokes that compose the crown of a palm tree and, at one and the same time, paint the background with a variety of ochre tones.

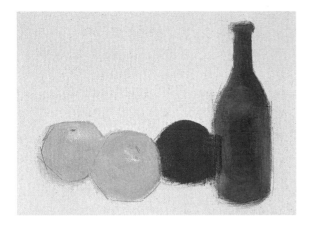

Beside the bottle, a strong red complements the green. The whole is compensated by yellow areas.

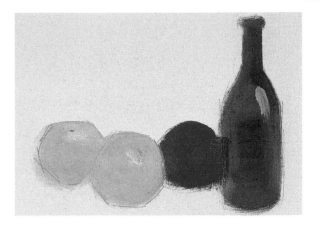

To compensate the balance between tonal contrast, a much intensified yellow has been applied to the bottle.

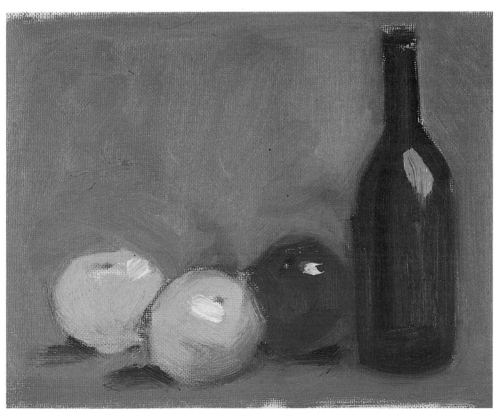

The background was painted with a mixture of all the colors used to balance the whole.

When a complementary color is used among other colors, the result is a very strong reciprocal contrast. It is very important here to have a correct classification of the colors and of the layout.

Cool colors

Still life with apples

Materials required

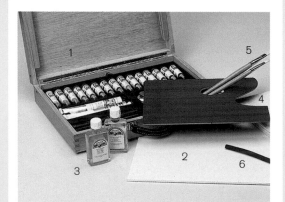

Box of oils with palette (1), canvas board (2), linseed oil and turpentine (3) cloth (4), brushes (5), charcoal (6).

When you choose to work in a determined color range, the picture's result, quite logically, inclines toward a given series of values. In this unit we have developed the application of brushstrokes to explain the different planes of the picture and simultaneously set out the option for a single chromatic range, concretely, the cool colors.

The still life suggested here is very simple. It consists in using three simple elements that have circular forms. You should pay special attention to the range of tonal values in this exercise, basically made up of cool colors. Another point to bear in mind is the process of doing the underpainting.

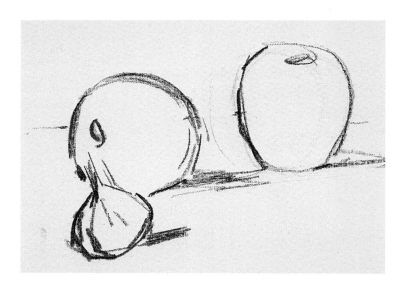

 1

As is habitual in the majority of the pieces done in oil, the sketch is in charcoal. In the first place, this is a way of using a medium that erases easily and can be corrected at any time. Second, charcoal allows you to immediately paint over its surface without leaving a trace of its line.

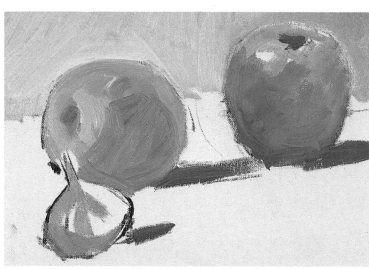

 2

Cool colors, like the rest of the pictorial range, can include many varied and mixed values that include the neutral colors.

To neutralize a color, mix it on the palette with its complementary color and white. This provides good background hues. On the palette, start with white and add some blue, then a pinch of carmine.

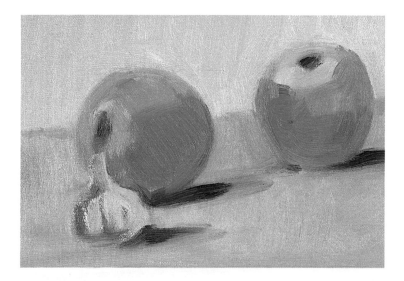

 3

The base of the table is also painted in a muted color close to white but slightly difference in comparison with the background. This area includes a stronger blue palette. Add some greens also, mixed with the neutrals obtained earlier.

The shadows of the apple were painted in Prussian Blue slightly intensified with white.

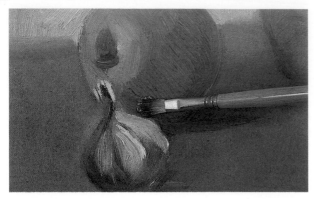

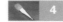 4

The head of garlic is painted on the basis of the brightest areas: these brushstrokes are very luminous and done on a violet ground. Mix bright green with yellow and paint the highlights on the apples.

With the brush loaded lightly with dark green, paint the darkest areas of the apples.

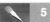 5

With yellow right out of the tube, paint the highlights of the tops of the apples using direct, very free strokes.

Use Neapolitan Yellow toned with bright green to paint the transition area between the light and shadow. A slightly toned violet should be used in the shadows of the head of garlic. The shadow of the garlic should be painted in the same way as that of the apples.

 6

To finish, a series of strokes over the previous layer will fuse among the tones.

These strokes should not be with a very loaded brush. Simply pass the brush over the surface to fuse the colors.

The initial brushstrokes are very free and spontaneous. As the picture proceeds, use a caressive stroke and fuse the color over the surface.

In the apple, the brightest highlight is done with Neapolitan Yellow and white.

The white is painted directly from the tube with a close brushing.

In the apple, use yellow toned with green.

Carmine and blue can be mixed to get violet for the head of garlic.

Nuances in the chosen color range

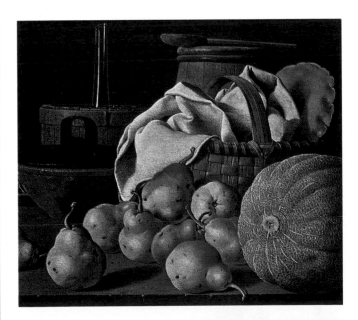

A given chromatic range can share colors with other ranges, as in this work by Luis Meléndez (1716-1780) titled Still Life: Pears and Melon. It is in the Museum of Fine Arts, Boston.

There is a dominant warmth in spite of the fact that a large number of cool nuances were used. This warmth is achieved thanks to the incorporation of cool hues softly nuanced with earth tones in the mixes on the palette.

The brush treatment is important. In this case, it is very fine and delicate in areas where care was taken not to leave bristle traces.

6 Brushstrokes

The marks left in the paint by the hairs or bristles of the brush bestow great expressivity and define the style of the artist. When painting in oil, some zones need a brush technique that permits fusion of colors; in other parts, however, this is avoided. It's a good idea to become familiar with the brush and use the most adequate strokes for each of the parts of the painting.

Working the brushstroke

Oil has a pasty consistency but is also smooth. This facilitates all types of techniques: dragging the brush, lines, patches.... Certainly, a whole series of effects is possible, permitting the creation of many different imaginative subjects. The present unit will study adequate ways to use the brush according to the object you desire to paint.

THE FORM OF THE BRUSHSTROKE

The brushstroke can acquire numerous connotations according to the way it is drawn across the surface of the canvas and according to the pressure used to lay the paint. If you paint with heavy strokes over a fresh surface, the stroke will drag part of the layer underneath into the one being applied.

On the other hand, if the brushstroke is painted with precise motions, with little or no dragging, the mix of the layer below will be minimal. Finally, if the color is laid on a completely dry ground, you'll be able to draw all kinds of work with the brush without mixing with lower layers or muddying the color. The form of the brushstroke is conditioned by the density of the paint, the drag, and the dry/wet stage of the layers previously applied. Depending on the form of the stroke, colors will fuse or else the stroke will be cleanly superimposed.

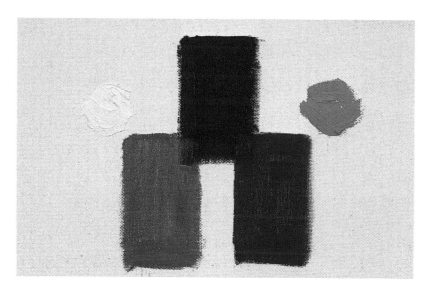

A red intensified with white gives a pink tone. For orange, however, you need to use yellow.

FUSING TWO COLORS

Painting carefully on a recently laid layer of paint you can superimpose strokes without mixing tones. This will be the first way to mix two colors by fusion on the pictorial surface. It allows adding many nuances to the colors being laid. The amount of paint placed adjacently will also influence in lesser or greater measure.

SOFT TRANSITION

When it is a question of making a soft transition between two colors, it is important for the original colors, before the edges touch, are left unmixed with the presence of the superimposed paint.

TONING

Fusing two colors is not difficult. The only thing you need to do is pass the brush repeatedly over two freshly laid colors, using long strokes that incorporate part of each color where their edges touch. After a few passes, the two colors will fuse in a soft, progressive toning process.

TOUCHING UP

Brushstrokes can acquire an infinite number of characteristics according to the way of drawing the brush over the colors. At times the line will be soft, hardly showing the mark left by the bristles. At other times, the line will show perfectly the cut of the brushstroke.

DRAG

Each type of brushstroke corresponds to a different paintbrush. According to the brush used, the amount of drag will change.

The exercise proposed at this point will take us from the phase of laying the toned ground to the fusion of two planes. The exercise is one of basic brush use involving blending in a single zone.

First, paint the widest planes. While no drawing exists, bear in mind what the next facet is going to be. This is important because you want the mix to come about between precisely these two. If you paint two much and move into the area where you want to lay the next load of paint, both hues will be contaminated.

In this phase, use a wide brush. The next load of paint adjacent to the preceding one and the amount of fusion will depend on how you superimpose. In this case, our interest is to blend only the edges. Hence, we won't use the same wide brush but a medium size one that discreetly joins the edges.

USING DIFFERENT BRUSHES

We've just seen how each brush has a touch that is expressed by the degree of drag over the painting surface or over other colors. It will now be possible to use different systems of fusing colors and the particular feel or touch of each brushstroke to create different areas in the picture. With this simple practice we can begin to learn about the properties of each brush type: drag or fusion.

The brushstroke

To fuse two colors without having the edges mix, paint one color beside the other but leave an unmixed border.

When a stroke is done to extend paint over the canvas, initially its form will be governed by thickness and drag.

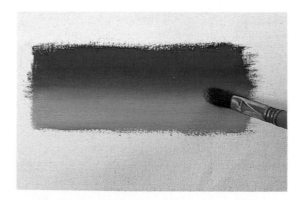

To fuse two colors, pass the brush softly and strokes the length of the patch being blended.

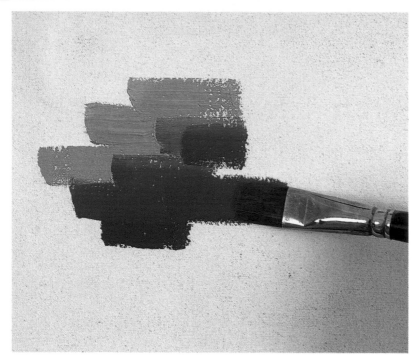

The first brushstroke is in yellow. On the palette, add a little red to this yellow and apply the toned result in a new brushstroke over the first layer. Continue in this way progressively until you're painting directly with red.

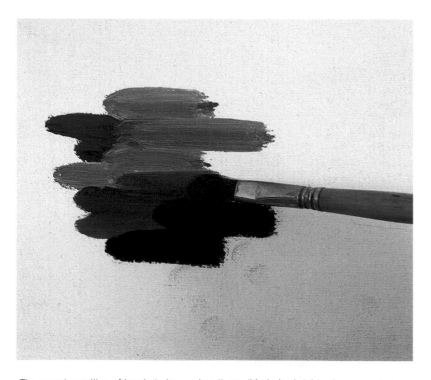

The superimposition of brushstrokes makes it possible to lay bright values over dark ones and vice-versa. The colors don't mutually contaminate each other. Compare the difference between the first exercise and this one.

BRUSHSTROKES TO COVER VARIOUS ZONES

Large painted areas in a picture can be covered rapidly if you use a brush as wide as the area you desire to paint. The type of brushstroke has to be long and uniform, without letting the brush leave lumps of oil on the canvas.

TEXTURED STROKES

There is a type of brushstroke that is very different from those we've seen, one which makes it possible not only to color the surface but also to give blended color value to the form you're painting. This brushstroke is highly varied and facilitates the creation of textures due to the direct mix on the canvas. The adequate brush for this task is usually any of the medium sizes.

Too small a brush is hardly able to effect some mixes, and its covering capacity is minimal.

First, load the clean brush with a bit of white. Use this to work over some of the blue ground, fusing the two with insistent long, horizontal strokes.

Now use an earth color—for instance, burnt sienna—to begin painting the mountains in the upper third of the picture. Here, you should drag part of the color of the sky onto the upper parts of the mountains. The resulting fusion should make up part of the texture.

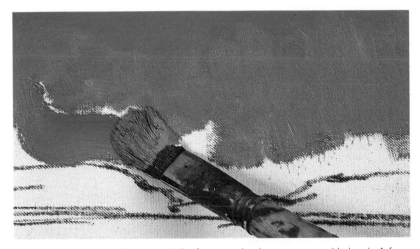

If you wish to cover a wide area rapidly—for example, sky—use a very wide brush. A few strokes will suffice.

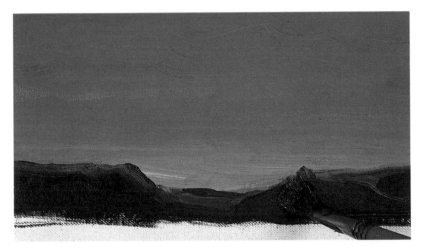

Over the sky add a few strokes with the brush lightly loaded with white until the colors fuse. The mountains will be painted with an earth color that takes part of the blue.

THE SMALL BRUSH

The small or low-numbered brush is no good for covering extensive surface area. But it's ideal for very detailed textures. These are usually lone in the parts of the canvas closest to the viewer, or else for special detailed effects.

LONG AND SHORT BRUSHSTROKES

To configure the middle and far distance: Use a long stroke, combining different colors: green, yellow, brown.

SERIES OF STROKES TO PAINT A PLANE

In the preceding subsection, we saw how different strokes make a wide variety of tasks possible in every canvas. Now we can get some in-depth knowledge on this by painting a piece in brushstrokes to cover a single facet. In this case, the facet is an evening sky.

In the first place, with a wide brush, cover a wide area of sky. Over the fresh oil base, fuse the new color. Be direct, as the minimum of pressure in dragging the brush will move the layer underneath.

The brushstrokes in the lower third of the canvas are short and vertical.

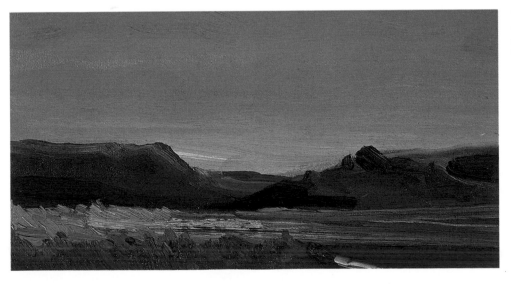

Contrast

When painting a wide area, be careful to bear in mind where the next color will be laid.

Fuse the two areas by touching up their edges with a soft brush.

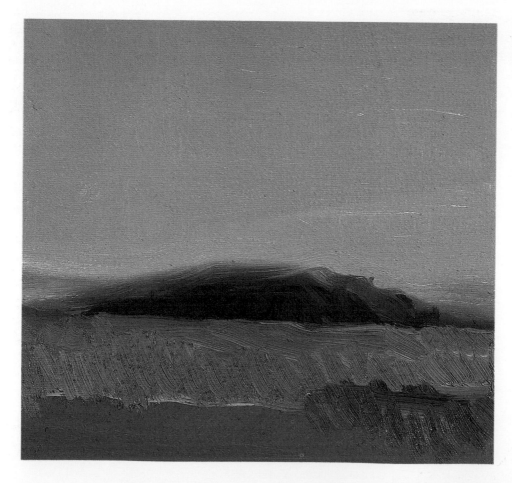

The foreground was done in two different tones. However, there is no fusion between these.

The underpainting's large areas can incorporate a darker tone that fuses with the light one.

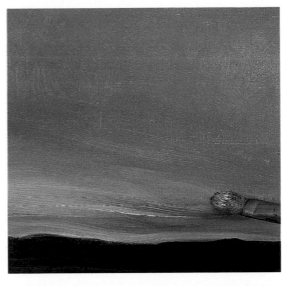

In the middle of the sky the brush bore a light load of color. The stroke must be insistent and always in the same direction and for the same length.

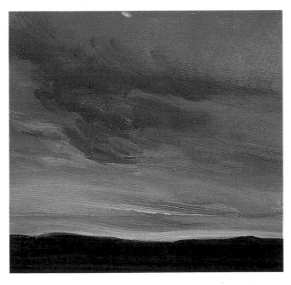

The purest hues are painted as they come from the tube, over a base of fused tones brought about by the drag of the brush.

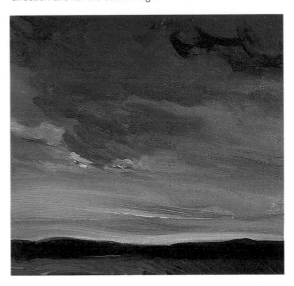

After softly fusing the last values over the upper sky, add new touches of orange.

In some areas a new brushstroke should be used which, instead of fusing with the blue ground, is laid on superficially, impacting on the initial yellow. Paint orange over this. The process is the same: in the upper zone, draw in insistent long strokes to fuse the tone underneath and, as depth is reached, use a more direct stroke. Finally, touch up with pure orange which, important-ly, shouldn't fuse with the blue but with the initial orange.

Paint a new, darker blue tone in the upper sky. This color adds to the initial blue through soft dragging strokes thatgenerate a gentle blending of colors.

As your use of this dark blue continues, add some orange values on the right.

When these fuse with the blue, the violets will come out.

Working the brushstroke
Landscape

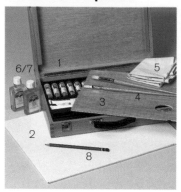

Oils (1), canvas board (2), palette (3), brushes (4), cloth (5), linseed oil (6), turpentine (7) pencil (8),.

This exercise more fully introduces use of the brushstroke. You should notice the interpretations of the textures of water, leaves, and white water in the foreground, which depends on different brush techniques, and the nuancing of colors to confer volume on the forms.

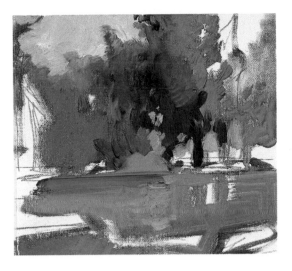

Begin the underpainting with the sky, mixing a highly intensified blue. The trees in the upper half of the canvas should be worked out first, using very general strokes in thin paint.

The first sketch is done in pencil to lay out the main masses of the picture and separate the planes of each of the areas.

The brushstrokes for the trees grows progressively more concrete: a) tiny highlights; b) contrasts.

The difference between the brushstrokes used in the woods and those in the water is clear enough: the trees are in short strokes superimposed with only slight drag over the base colors; the water is done in long strokes fusing ochre, blue, gray. The foregrounded white water at present is a series of grayed values.

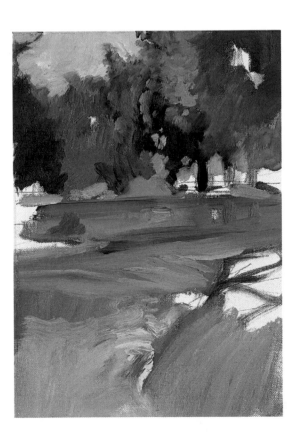

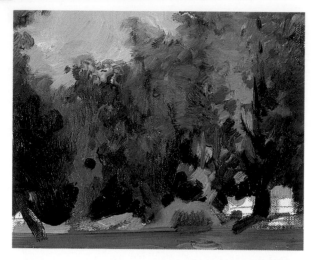

Pay special attention to the wooded area. The strokes are now short and include tiny notes of very bright yellow. This brushwork employs a fine brush and the yellow is kept from growing muddy or contaminating the green.

Medium size brush now: paint the colors you want to make up the main contrasts in the trees. Portraying the shadows of the lower zone of the wooded area requires insinuation of the forms of the trunks.

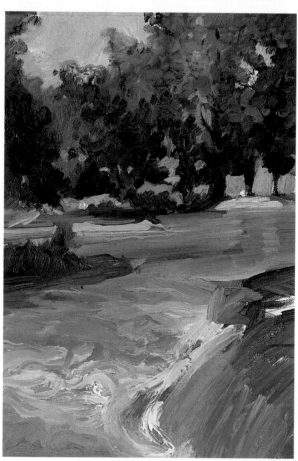

New brushstrokes on the water surface bring out the contrast of the shadows on shore (painted in ochre). Complete definition of shore in white, bright green, ochre.

Last contrasts in the trees and some free strokes of white in the swirling water in the lower third of the picture.

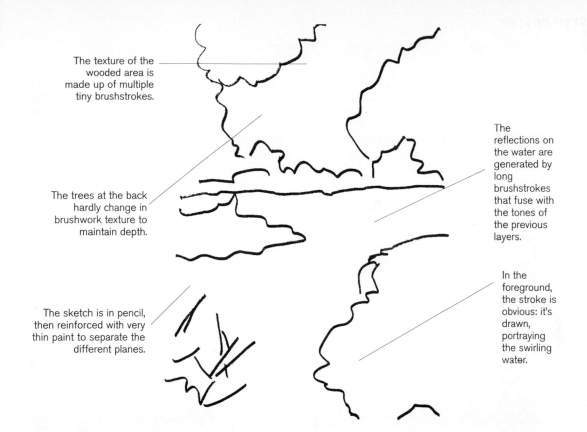

The texture of the wooded area is made up of multiple tiny brushstrokes.

The trees at the back hardly change in brushwork texture to maintain depth.

The sketch is in pencil, then reinforced with very thin paint to separate the different planes.

The reflections on the water are generated by long brushstrokes that fuse with the tones of the previous layers.

In the foreground, the stroke is obvious: it's drawn, portraying the swirling water.

Glazed contrasts

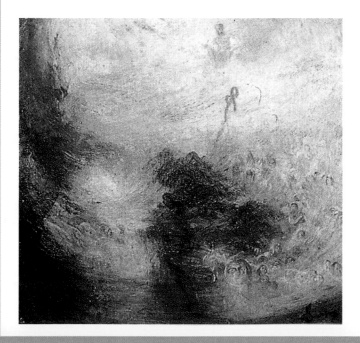

In this piece, Turner was ahead of his time in terms of ideas that would greatly interest the Impressionists of the end of the nineteenth century. The almost magical light of this picture is achieved thanks to the superimposition of very transparent glazes that affect the colors of the previously applied layers. The ochre nuances softly with the whites and generates the atmospheric effect desired by this great artist.

Masses of color

Oil painting is a pictorial procedure with enormous chromatic possibilities due to its vast richness of nuances and its great luminosity. To use these qualities to full advantage you should be familiar with the theory of color and the ranges of colors.

Building through color

The masses of color on the canvas are applied progressively, but not only in terms of a fat over lean process. Once the simple, indispensable procedure is acquired, it should be practiced as a way of building up the picture.

In this unit we will set out a series of exercises that hold great interest for those who wish to continue the study of oil technique. Up until now, different effects have been practiced in regard to brushstrokes, the development of the underpainting, and layering. Now, these concepts will be applied in greater detail.

SUPERIMPOSING COLORS

We've seen how a color laid on a previous layer of fresh paint drags part of the lower level and generates a slight tonal variation. Often this aspect can greatly aid the painter; however, on some occasions uncontrolled drag can give rise to unexpected mixes if color theory is incorrectly applied.

THE SKETCHED UNDERPAINTING

If we know in advance the result of different mixtures it is possible to plan a picture by intuiting the different areas of color to be superimposed. First, in the underpainting, in addition to observing the now well-known norm of "fat over lean", must be built up progressively.

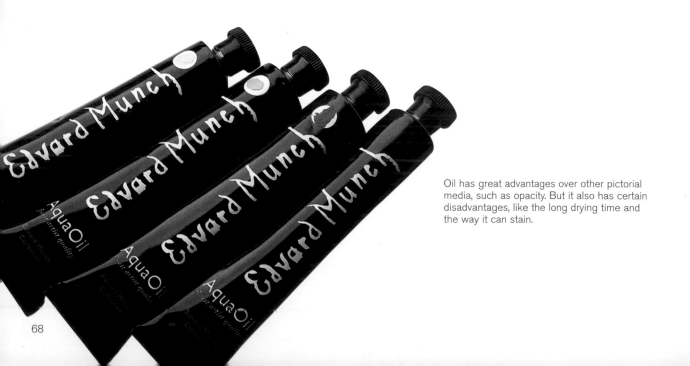

Oil has great advantages over other pictorial media, such as opacity. But it also has certain disadvantages, like the long drying time and the way it can stain.

Mixing color

Basic color mixes

Neutral color mixes

DIRECT MIXES ON THE CANVAS

The progression of the first layers doesn't use detail until the process is rather advanced. All the work done in the first layers is aimed at applying the first tone values to serve as base for subsequent layers.

As a result of mixing done right on the canvas, a number of tonal variations are achieved.

THE IMPORTANCE OF PAINTING THE BACKGROUND

Building up the picture in a well-ordered progression is only possible if you use the correct distribution of the colors on the toned ground.

- The first color areas should never be very pasty.

- The hues should be perfectly ordered so as not to drag more paint than absolutely necessary.

- The small contrasts between the masses at this stage should prepare a sufficiently wide and stable base.

- When the colors of the underpainting have been laid on the general areas, you can control the forms by the contrasts that configure them.

FROM GENERAL TO PARTICULAR

Lay on paint progressively and with growing detail. As the most important masses in the picture are established, the ground will end up covered with color and enable the incorporation of new nuances over the previous ones.

As we studied in previous units, the progression of oil is always done via paint thinned with turpentine prior to moving to impasto work. It is precisely this type of brushstroke that makes possible the planning of a much more precise and concrete underpainting.

This point should serve you well to develop any task in oil. Always create the general idea before going to details. A very simple scheme of evolving the picture would be: fat over lean, detail over underpainting.

The first masses of color should be quick and general, leaving details for later. What you want at this stage is to cover the ground with basic colors.

As the underpainting progresses, the color masses are converted into a variety of tonal values.

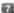

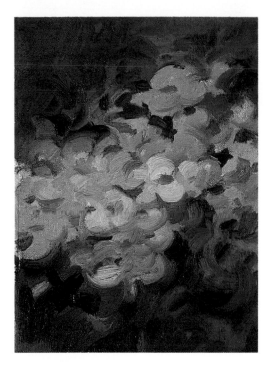

Contrasts not only get built from the addition of dark hues, the lighter strokes also enable formal profiles.

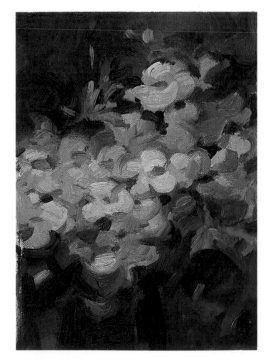

Details grow much more concrete when the underpainting over the ground is comprised of perfectly studied masses of color.

THE FORMS LOSE DETAIL IN THE UNDERPAINTING

When amateur painters begin to paint, they confront an important problem: slowly, the well-executed sketch of the underpainting is covered with thicker color, thus filling the canvas with a potpourri that makes it into something unrecognizable. The newly trained painter should practice enough to leave out details initially and establish the underpainting with large color masses. This work will slowly be enriched as the picture process proceeds.

RECTIFYING FORM IN SUCCESSIVE LAYERS

The fact that oil is painted fat over lean makes it possible for the first layers to be done rapidly

Forget the details when planning the initial color. This is true for any subject you paint.

The initial scheme, whether sketched in charcoal or in oil, can be completely covered in paint. This is not important so long as you can re-do the sketch no matter how complex. What is definitely fundamental is painting generally first, using large masses that unify areas.

LIGHT TONES OVER DARK, THANKS TO OIL'S OPACITY

Because oil is an opaque medium, it not only lets you rectify the painted form but also to lay light colors on dark ones.

You can paint white right over blue without any transparency in the former.

DRAW AS YOU PAINT

The concept that the form is redrawn as you paint will be difficult to follow in your first pieces, but with practice on different types of pictures you'll acquire the knack and understand the theory.

The sketch, then the underpainting, is lost and recovered only in a processual move. To practice this, the following simple exercise is proposed. You'll be able to appreciate how the sketch comes back out of the mass of color and the later brushwork, and much more concretely.

THE DRAWING MARKS TH FORM

The beginning of the picture from a sketch must be made into constant practice. This doesn't mean the base drawing is unmovable. In fact, it simply won't be that way with oil. The initial sketch will serve as guide but color will constantly cover it.

PAINTING WITHOUT FEAR

While the drawing may be well done, you have to paint over it fearlessly and cover with color everything that can be considered accessory or detail.

The stems of the tomato have been completely covered by color. This large mass of color takes priority over the internal forms, although the circular outline is as closed as possible.

In spite of the fact that the original form is destroyed, it is important for the drawing to be well laid out because it serves as guide for the remainder of the piece.

DRAWING WITH PAINT

Once the picture acquires its principal mass, you can re-do the original form of the tomato and the internal details. If you'd done this before, the colors would have gone muddy.

The detailed brushwork should always be done when there are no obstacles in the way.

GENERAL FINISH AND DETAILED FINISH

As to later work with color, it all depends on the level of finish you desire. What is fundamental is always to observe the same process for any area of the canvas. For example, when painting the background, the lines of the stems will be covered. Once the surroundings have been laid on, however, the stems will be redone much more precisely. The highlights on the leaves will also be painted, of course, but only when all the color masses are considered finished.

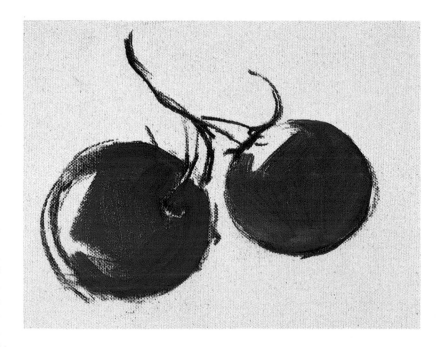

In the pictorial process, large masses of color cover the drawing of the stems.

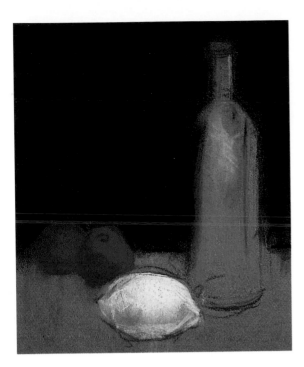

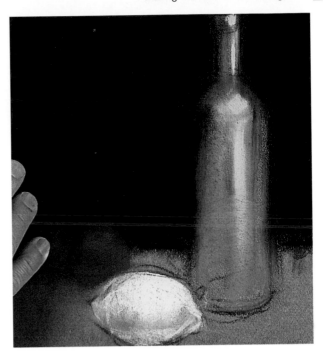

4. The pieces of fruit that have been painted in the background have a certain importance, but they do not contrast sufficiently over the base color. This contrast is achieved with a simple darkening of the background. The strokes are made as they were in the first intervention, but with the difference that the color of the background can now be used as a tone that breaths through the new contrasts.
Darkening all of the background, the picture takes on a great luminosity.

5. In order to separate the different planes of the still life, all of the elements of the most distant plane are integrated into the dark background. This is achieved by gently blending the profiles of the new elements into the background so as to soften their forms. It is not a question of mixing the colors, but of blurring the outline of the pieces of fruit.

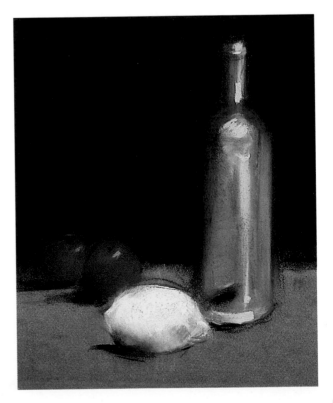

6. The reflections and highlights allow the necessary luminosity to be given to the group. In the foreground, the reflections can be made in a much more direct way. In the middle ground, these reflections have to be a lot less defined.

BACKGROUND AND SUBJECT

The principal subject matter of a painting is not always found surrounded by other elements. It is often stands alone and isolated over a completely plain background or one made up of various colors. If this is the case, special attention should be paid to the composition as if the principal elements are badly placed or should any misbalance be detected, the background may seen to be incomplete. However, this inconvenience can be resolved with a simple intervention over the background which is often much simpler than could be imagined.

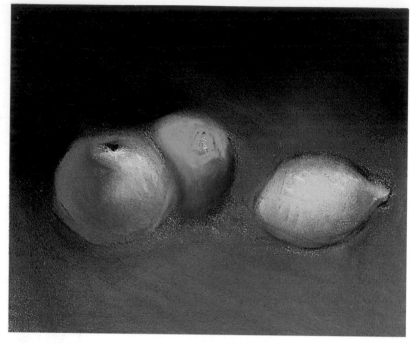

1. The pieces of fruit that make up this still life have been laid out and developed over a neutral background. Nevertheless, the relationship of these elements with the group seems to be lost in the space that surrounds the principal elements.
It is not a question of a poor use of technique, but of an incorrect relationship having been established between the background and the subject.

2. It is not very difficult to correct the balance between the background and the subject. Some small interventions, such as shadows and the foreground being resolved in diagonal, give the group dynamism and help it acquire unity. Small aspects such as these are often missed by the enthusiast. However, if exercises such as this one are undertaken, the balance between background and subject matter will become something that is resolved in a very natural way.

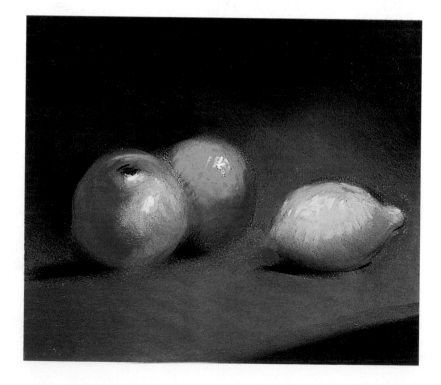

PAINTING AND BLENDING
OVER COLORED PAPER

In previous themes, we have seen how the color of the paper has been used as the base for the color scheme developed in the painting. Given that colored supports strengthen the qualities of pastels, it is important to make the most of this factor whenever possible. The following exercise shows a very simple and intelligent way of integrating the color of the paper in the final result by combining patches of color and reserves of color.

1. The initial layout is drawn in light-blue pastel and the forms of the flower, which will be kept in reserve, are established. The color of the paper will be decisive in the final tones of the painting as well as in the first marks that are made in it.

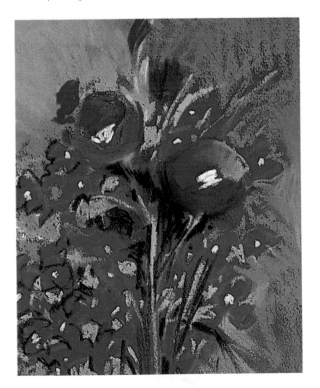

2. The flowers are painted in bright colors which are applied with sufficient pressure to cover the grain of the paper in determined areas. For the poppies, carmine and pink tones are used. The blue flowers, on the other hand, are momentarily left in reserve given that they are of the same color as the color of the paper.

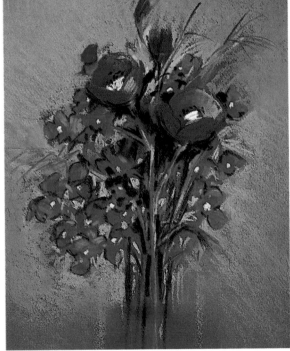

3. The reflections over the blue flowers are obtained with small touches of very light blue pastel. In some areas, this bluish tone is blended into the background in such a way that it integrates perfectly with the darker blue.

75

Fixing

Flowers

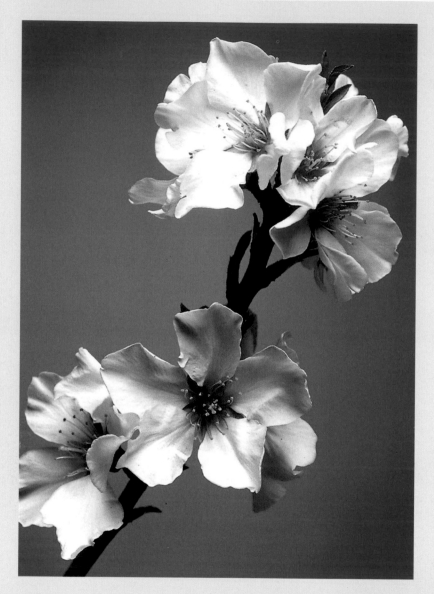

Materials required

Pastels (1), dark blue paper (2), an aerosol of fixer (3) and a rag (4)

Pastels, when used in an adequate way, offer the freshest and most spontaneous technique of all those used by artists. However, what started with great color and looseness can be completely ruined with a simple spraying of fixer at the end of the working process.

Fixer has to be used, but at the right moment and, above all, not when finishing the piece.

 1

As a very dark piece of paper has been chosen, the best way to lay out the drawing is with a few strokes in a light color. For this reason, the drawing has been developed in white pastel.

 2

The painting of the upper flower is started in a gray tone which stands out as a light color over the dark background. This seems to be a suitable color for painting in the areas of shade on the flowers.

With the addition of pure white in the lightest areas, all of the tones that are going to be used in the painting have been established. In order to isolate the definitive form of the flower, the background is painted in with navy blue, one of the most beautiful and luminous of pastel colors. With fingertips, some white is blended in over the blue background. The result is a new tone of blue that is much whiter that the previous.

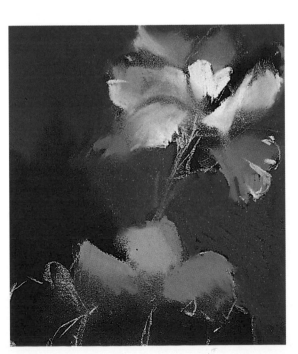

 3

The upper flower is painted with very direct applications of white over which gray patches are added in order to obtain the intermediate tones of the shadows. Without completely destroying the form of the petals, the contrasts that give too strong an outline are softened by rubbing. This fusion is extremely simple. The color of the background of the paper acts as the darkest point among the petals.

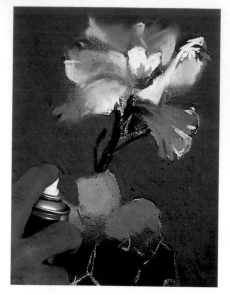

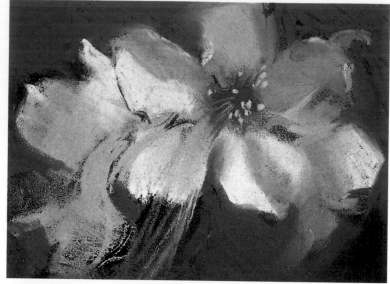

 4

In the upper flower, apply some very direct impacts in white so as to situate the brighter reflections. The center of the flower is drawn with a few strokes in orange and yellow. With rapid strokes and without going into detail, paint in the stalk. Once this has been done, apply a layer of fixer from a suitable distance so that the spray is not concentrated in just one place. The pastel should not become pasty. A small spraying is sufficient for the work produced up until now to be stabilized and made ready to receive new interventions.

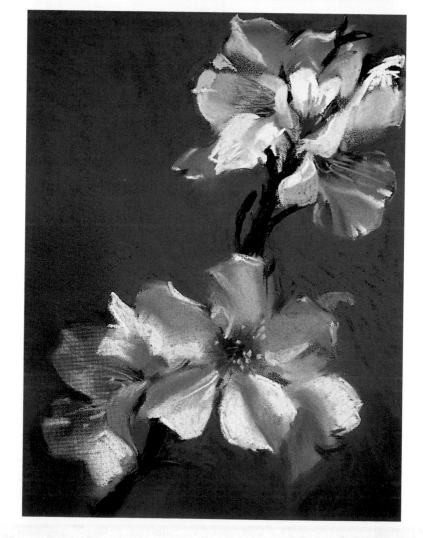

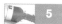 **5**

Details of color are added which are blended into the colors below. In this way, new tones of gray can be superimposed as precise highlights. Lastly, add in a few direct impacts in red and some points in yellow.

Dark colored paper suggests an initial layout in a light tone. In this case, it has been drawn in white pastel.

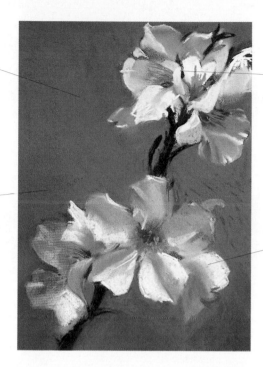

Details in very luminous white highlight the profile of the flowers as well as the strongest reflections.

A blue that is much brighter than the background allows the form of the flowers to be outlined. The most luminous points are established when the lightest tones are painted in.

The grays of the lower flower are painted over the previously fixed layers of pastel.

The Importance of the Paper

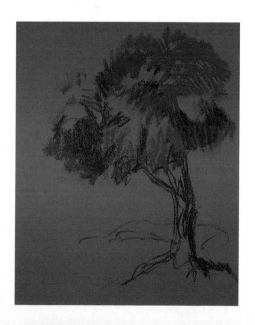

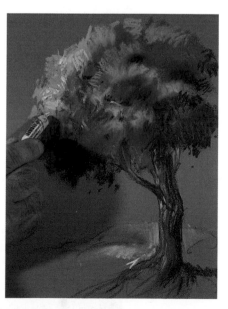

As the color of the background constantly breathes through the different strokes applied, the paper always takes on a great importance when it comes to painting in pastels.

Trees and Landscapes

Trees are often indispensable elements in a landscape. They sometimes require great elaboration and a large amount of detail. On other occasions, they can be insinuated with simple patches of green blended in over the background. In this theme, some examples that will provide models for later exercises are going to be dealt with. All types of trees in whatever landscapes can be painted with the techniques presented in these exercises.

The Structure of the Trees

It is essential to understand the internal structure of an object before starting to represent it on paper. As has been studied up until now, all objects and forms found in nature can be represented by other simpler elements and geometric forms. A tree can also be understood in this way. In fact, this can be seen more clearly in the construction of a tree than it many other object from nature.

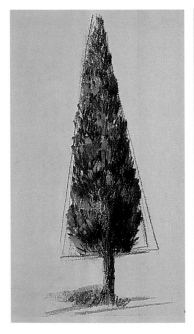

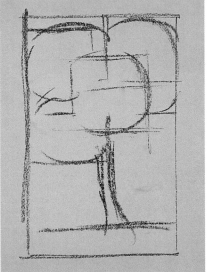

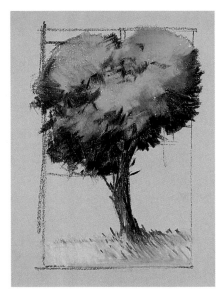

The triangular form facilitates the representation of trees with a conical structure such as firtrees and cypresses. Before painting this tree, its has been represented in its most essential form.

A tree of certain complexity can be accommodated in a simple scheme from which the internal rhythms of its branches can be understood.
As can be seen in this image, the tree consists of a rectangular form which has been divided into various sections to allow its trunk and branches to be described in elemental forms.

Once the overall form of the tree has been understood, it can be drawn and painted in a definitive way. First, the outline of the drawing, then, in its interior, each one of the marks and colors that make up its texture.

BUSHES AND VEGETATION

Landscapes often contain areas of high grass or bushes that need to be treated in a specific way: vegetation should not be represented in all of its detail, but it should be insinuated by means of softly blended mixed tones along with direct strokes. The real intention is to recreate the light and dark areas that make up the scene. The use of direct strokes should be limited to the elements that need to stand out and those that are closer to the observer.

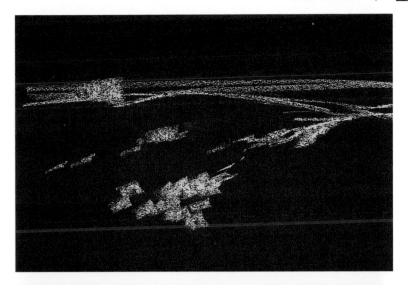

1. When creating a large area of vegetation, the reality is that each bush is not appreciated. It is a mass of green tones with some differences created by the changes in planes or the deep shadows produced in the different zones. When developing the area of bushes, it should be treated as just one object. Therefore, the area is laid out in a lineal way.

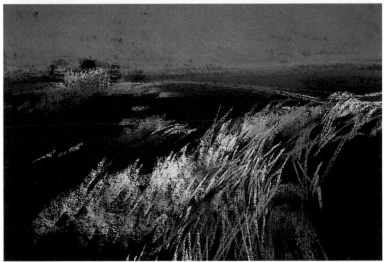

2. The area is painted in by zones. Different tones of green are used according to the degree of luminosity corresponding to each area and the limits between one and another are not clearly defined. A stroke is dense enough to leave an important quantity of pastel on the paper. These build-ups of paint are to be blended in with the fingertips in such a way as to give form to the different volumes of vegetation. In the vegetation at a greater distance from the spectator, the contrasts of the trees and bushes tend to unify into only one tone.

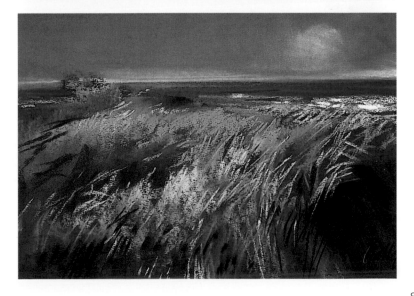

3. Once the tones have been blended in, new colors are applied that allow the shadows and contrasts to be painted in more precisely.
Odd strokes of colors are applied over the points where direct light falls.

Painting a Tree

In all painting techniques, the way the paint is applied is of fundamental importance. After the initial sketch, applying the colors is what guides the entire process of creating the picture. In this exercise, it can be appreciated in detail how to apply paint correctly so that the contrasts find their support in the light and dark tones. The direct character of a stroke of a pastel leads to a variety of options: the coloring in which the zones of light and shade can be foreseen as well as the definitive textures of the finishing touches.

1. Having established the layout, start painting in the tree. As pastel is applied in strokes, the painting takes on the form of lines that are straight, curved or as wide as the width of the stick of pastel. In this way, the first strokes always acquire a marked character of drawing. The lines used to start painting the tree principally fulfil the function of creating its volumes because a tree, unless we are dealing with a perfectly pruned hedge, contains a great variety of forms and each one has its own light and shade.

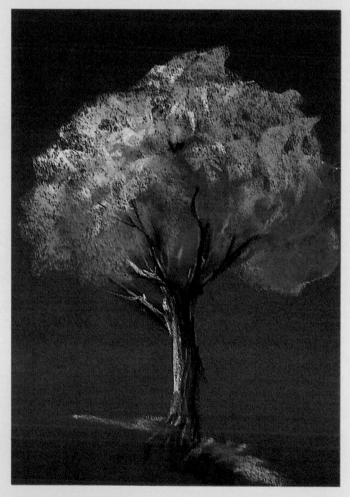

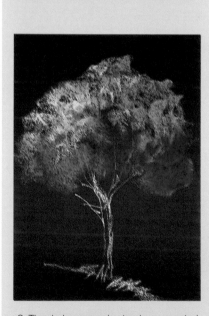

2. The darker areas having been created, the lighter zones are painted in. In this case, as colored paper is being used, the white stands out strongly.

3. After blending in the patches of color with your fingertips, finish the tree in the following way: add new colors, some direct and spontaneous that are not blended in, and others that are blended in, but which are not completely mixed with the colors that lay below them.

RESOLVING A TREE

As you will have been able to appreciate, pastels can be treated in an endless number of ways. From being painted in to receiving its finishing touches, the tree may go through a great variety of processes which are always based on the techniques of blending and applying direct strokes.

In this proposal, we are going to develop a double work in pastel. We are going to start with a piece of work that is fresh and direct from which we will learn how to resolve the problem of adding the texture to the tree.

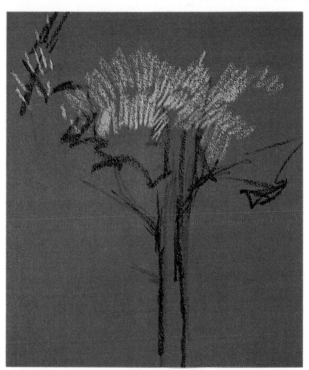

1. A piece of green paper is used. A number of zones on this piece of paper will be perfectly integrated into the painting, above all, the parts that coincide with this tone of luminosity. The first stroke made is completely drawinglike. Here, blending is inappropriate and not even the slightest blurring of the color is called for. Over this initial drawing, strokes in other colors are made, but the freshness and spontaneity of how they are applied is maintained at all times. These strokes are not blended and the painting is completely gestural.

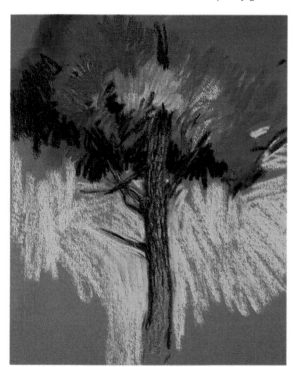

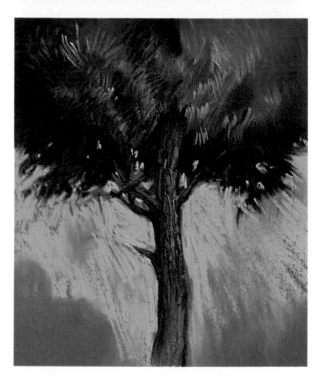

2. This first step only includes the direct work and the drawing in pastel. In this way, all of the surface as well as the space that surrounds it can be filled. Having painted the area that surrounds the tree in these luminous strokes, the trunk is perfectly outlined and, in the upper area, the color of the paper perfectly integrates among the tones of the top of the tree.

3. The zones that are to serve as a base for other layers of color are lightly blurred. Darker colors are painted over these blended zones which create strong contrasts with the other tones. Some of these dark zones are blended in over which light colors are painted. The rest of the work alternates the application of direct strokes with the blending in of the patches of color.

Representation

A Landscape

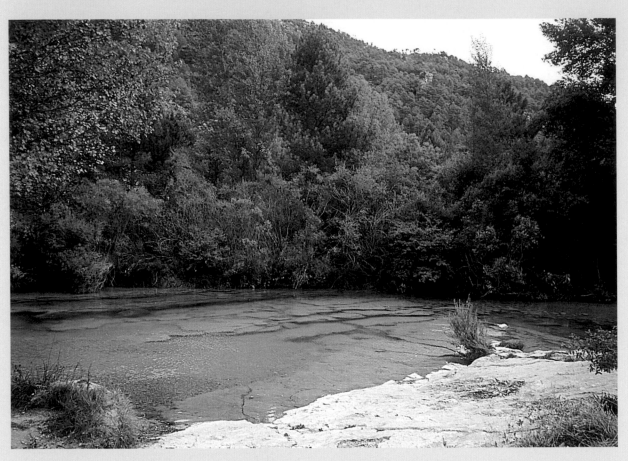

Materials required

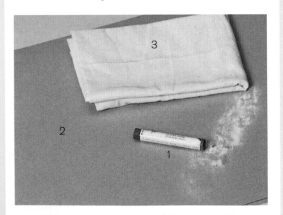

Pastels (1), cream-colored paper (2) and a rag (3)

Painting landscapes is directly related to the representation of the vegetable world. There are no particular rules when it comes to learning how to paint the great variety of details and richness of light and shade that makes up landscapes. However, there is a recommendation that you should always bear in mind: look at nature with your eyes wide open and put aside preconceived ideas. Who said that grass is always green? With a little practice, you will learn to differentiate the thousands of tones that make up vegetation. Do your best to represent them well and you will find that after the initial effort of seeing things as they really are that looking will become an automatic action.

1

To begin with, sketch the theme in a few simple strokes. Over the horizontal corresponding to the water, situate the zone of trees and bushes. Establish these with nothing more than their profiles. Also indicate the mountain in the background and the shore in the foreground.

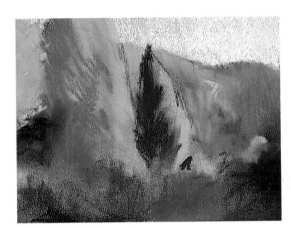

2

The lightest part of the trees is painted in a very bright green while the shadows are represented by a darker green. Allowing the color of the paper to become integrated within the strokes made and participate as one more color, paint in the foreground in white. Use a white blended in with Naples yellow for the sky.

3

The colors and blended together in the areas where they come into contact with each other. Some colors act as base tones for others that are painted in later. Examples of this are the violet tones over the shore or the cobalt blue to the right. The only area of the painting in which the colors are mixed together is the one on the right where a dirty color is needed. This zone has been painted in sienna, green and black. Mix lightly with your fingers until the colors are completely blended together.

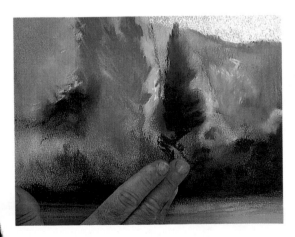

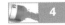

4

Luminous colors are superimposed over the trees on the left and the tones of the background are left to breathe through the darker strokes. With a finger, blend in some zones so as to bring out a contrast with the dark brown tones recently painted over the shoreline.

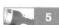 **5**

 6

Apply some green to the area over the shore. As can be seen in the image, the strokes are in a well-ordered zigzag situated at the level of the bushes in this plane.

With your fingertips, completely blend in the previously established dark strokes. In this action, the unpainted area below the shoreline is dirtied. Over this darker zone, the upper part of the vegetation that is illuminated by the sun is painted in a light green.

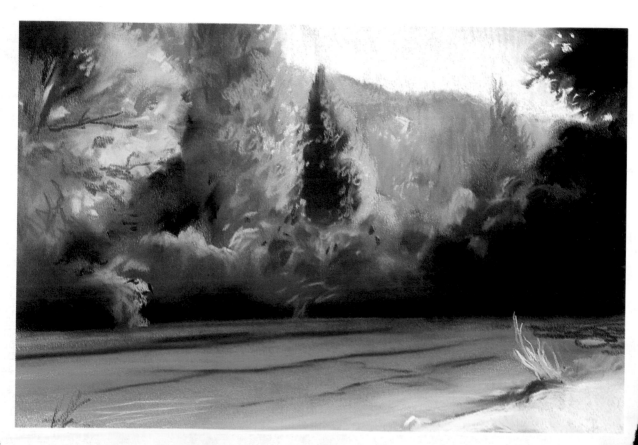

Before painting in the trees, a base of tones blended together is established.

The initial layout is highly schematic. Only the general forms of the trees and the shoreline are stated.

The foreground is painted in white. The color of the paper that forms the background is integrated into the composition.

Colors have only been mixed together on the right hand side where dirty tones were required.

The blending in of the water area has been undertaken without mixing colors.

The Magic of the Surroundings

Pastel allows patches of color and lines to be perfectly combined in such a way that, although some pieces can perfectly well be accepted as complete paintings by nature, the technique can be considered as being of either painting or drawing. In this work by Jean François Millet (1814–1875), La Siesta, from the collection of the Art Museum of Pennsylvania, a good example of this can be appreciated.

10 Skies in Pastel

The sky is one of the most important elements of a landscape and it is difficult to imagine a painting of a landscape in which it does not appear at all. As it is one of the most changeable aspects of the picture, it is one of the most interesting to resolve in pastels. On these pages, different skies are presented at different times of day and in a variety of meteorological conditions that show some of the many possibilities offered by this technique.

The Colors of the Sky

The color of the sky is by no means unique. In fact, any color from the rainbow may be present in the sky at some time. The atmosphere, the time of day and the meteorological conditions are aspects that determine the color of the sky. On these pages, we can see some sketches in color from which a great variety of skies can be developed.

1. The creation of a sky can be based on various colors arranged in a sequence. In order to make a start, order the colors in a natural way and emphasize those observed in the scene in question. Here, it is almost impossible to exaggerate as nature can include far more colors than those found on the most colorful of palettes. The colors should be initially established without blending and by one tone overlapping another.

2. With your fingers, blend in each zone of the sky. The order in which the colors are blended together is important as some of the zones have to be blended in, but kept clean at the same time. In this example, the blending has started in the upper area. The colors have been fused together with delicacy to do no more than break up the difference from one to another.

3. Once the tones have been blended together, some of the details can be approached by using the point of the stick of pastel. These touches allow reflections and different luminosities present in the sky to be accentuated.

CLOUDS

Clouds exist in many forms, colors and textures. In spite of the fact that their forms may seem to have been formed in a caprice way at times, condensation does not take place at random, but it is governed by conditions that order it in cumulus, cirrus or stratus formations. The altitude of the clouds, their density and the time of day allow more or less sun to shine through and, therefore, some areas of the sky are illuminated more than others. In this exercise, we are going to paint some storm clouds. Pay attention to the blending of tones and to the points of maximum contrast.

1. The choice of paper is an important question if we intend to use it as a background color. In this case, a gray tone will help represent these storm clouds. In this exercise, not even the smallest of openings is going to be seen in the cloud formation which means that all of the work will fall on the elaboration of the clouds. The first step is to draw the most evident forms suggested by the cloud formation. In this way, the main areas of light and shade can be foreseen.

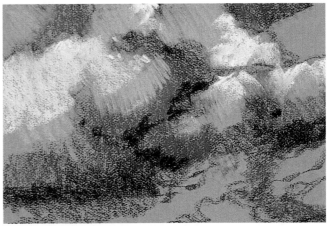

2. The middle grays are initially left out as we later wish to make use of the color of the paper. However, the lighter tones are painted in ivory, pure white or even in Naples yellow. The darker tones that correspond to the areas of shade are also painted in. As can be seen, the color of the paper integrates perfectly with the clouds although the tones applied have not as yet been blended together. The volumes have been perfectly established thanks to the principal points of light.

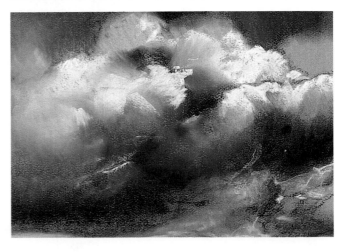

3. Las tonalidades oscuras y las claras se funden sobre el papel con ayuda de los dedos; de esta manera se pueden modelar las formas de las nubes. El fundido se realiza con movimientos curvos. Una vez que se han fundido todos los tonos, se pintan aportes directos que perfilan y recortan algunas zonas.

SKIES AND HORIZONS

The simplest skies to paint are those which are clear or which contain no more than a few clouds. In these cases, strokes have to be applied with particular delicacy as skies, as we have seen in the previous exercise, can be enriched with a great many details. On this page, we are going to look at a clear sky and how the colors change as they go down to meet the horizon. A simple exercise which will undoubtedly be useful when dealing with an endless number of situations in landscape painting.

1. A good way to start painting a clear sky is in the higher areas as it is here that the colors are almost always darker and purer. This is because the atmospheric layer gets thicker as we look at the sky nearer the horizon. Other colors lie below this first band and a stepping down of tones is created. It is important that the color situated just above the horizon stands out for its luminosity as it is at this point where the atmospheric layer is thickest and filters the colors of the sky.

2. No more than a soft rubbing over the strokes applied to the area of the sky is necessary to bring them together into a mass of homogeneous color and to unify them with the other colors that so far make up the painting. As it is very easy to contaminate the lighter luminous colors with the darker ones situated in the upper areas, special care should be taken when moving on from one tone to another.

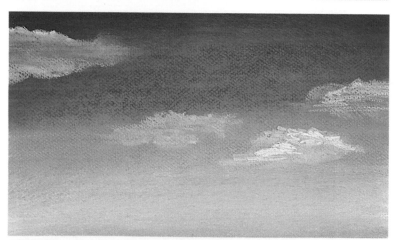

3. Final details between the tones allow for luminous touches to be added to the blended area. Over this colored base, numerous modifications can be made such as can be appreciated in this last stage in which some clouds have been added.
Another important question is how the whites should be treated. As can be seen, pure white is not applied except in those absolutely luminous zones.

THE TIME OF DAY

It has already been mentioned that the skies vary according to the movement of the sun. The change is constant. In this exercise, we are going to work on three different skies based on the same landscape, but at different times of day. The first is at dawn, when the horizon is tinted with reddish tones; the second corresponds to a luminous midday sky with details of yellow on the horizon; lastly, we are going to paint the sky at dusk when the blues become mauve and darken.

1. The sky at dawn and during the first moments of sunset can be identical. The sun on the horizon saturates the atmosphere with reddish tones and produces colors that are almost unreal in the lower areas. With pastels, these effects of color and light can easily be achieved even after having established the original colors. However, special care should be taken when blending the tones to ensure that they do not dirty one another.

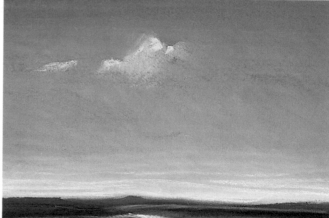

2. At midday, the sky is at its brightest and the blues become saturated and pure. On the horizon, depending on the day, changes in tone can be observed. On particularly hot days, depending on the zone, dust in suspension that gives off reddish or yellowy tones is seen.

3. Highly contrasting tones are always produced at dusk. On one hand, the colors are typical of night, deep blues or violets. On the other, they are of the remaining light of the setting sun. These last rays of sun are represented over the paper in pink and orange pastels that capture the heavenly scene. In this case, special care should also be taken with blending in the tones as we wish to maintain the freshness and vitality of the more luminous colors. These tones loaded with light are painted, blended and superimposed in the last stages of the process.

The Colors of the Sky

Dusk

Materials required

Pastels (1), gray colored paper (2) and a rag (3).

Creating the sky can be one of the most pleasing and enriching tasks that can be undertaken in pastels. It is not necessary to have a highly elaborated drawing to begin with. The creation of certain types of skies does not require the effort that has to be made when it comes to other subject matter. In addition, creating a sky brings spectacular results when the most adequate moment of the day is chosen. The example proposed displays this well.

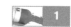 **1**

The initial drawing does not have as great an importance as it has when dealing with other subject matter. However, it will serve as a perfect guide when it comes to elaborating the different planes of the picture and to situating the colors in an adequate way. These strokes are made with the point of the pastel in such a way that the outline of the terrain is differentiated from the form of the clouds. While the terrain is defined with a darker tighter drawing, the clouds are worked in a much looser way.

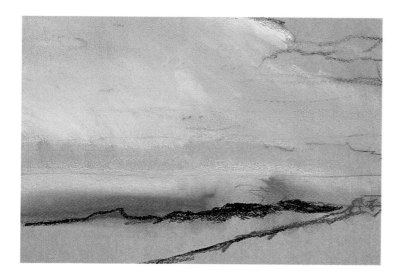

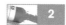 **2**

Start by painting in the more luminous tone of the sky in which the reflections of the sun can still be seen in the clouds. These initial colors combine different tones of yellow among which some orangy aspects are found in the line that marks the horizon. Having applied the pastels in strokes, rub your fingertips over the colors so as to blur the lines made.

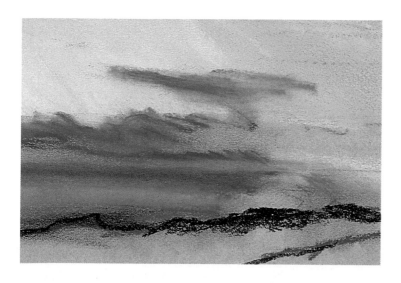

 3

Over the border of the orangy patch on the horizon, draw in a band of bright pink. The bottom parts of the clouds are to be painted in violet and the tone enriched with a few touches of blue. Pay attention again to the lower border of the clouds. Over the pink area, add a thin line of blue and, with your fingers, blend it in until obtaining a tone that is a little dirty, but very localized.

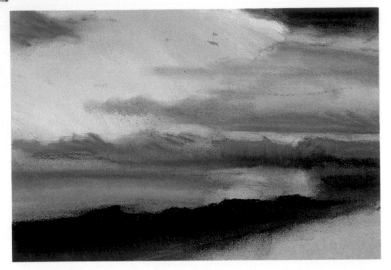

 4

All of the lower part that corresponds to the mountain is painted in black in a very direct way although the lower zone of this plane is stepped down in color and blended in with the background by mixing in a little of Prussian blue. Dark blue tones are also added to the sky: black in the top right hand corner and blue in the empty areas left by the patches of yellow. Some parts of the sky are blended in which dirties determined zones in a carefully controlled manner.

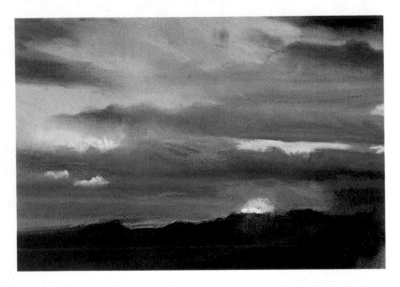

 5

The denser grays of the heavenly dome are painted in. The contrasts with the more luminous tones are highlighted thanks to the adoption of much lighter colors which border with the darker ones recently painted in these zones. These tones of light are not white, but variations of a very light Naples yellow. The setting sun is painted with a diversity of yellows, Naples yellow and orange. The foreground of the terrain is painted in a very dense black tone that contrasts with the graded colors previously painted in.

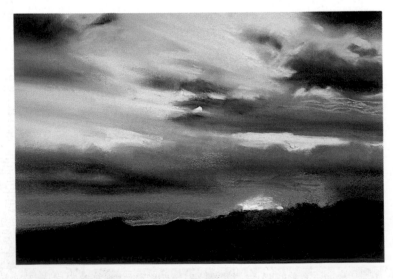

 6

Over the yellowy clouds, fresh tones that are much more luminous are superimposed over the darker ones. With black pastel, darken some of the zones which were previously painted in blue tones. The bottom left-hand corner of the zone corresponding to the terrain is painted in blue and tones of black and blue which are blended together. The base of color that has been created is now a perfect background on which to establish details of luminosity which are applied in the form of direct impacts, in lineal strokes or as touches of fusion over the tones that lie below.

The first colors that are applied are the most luminous so that the darker and more contrasting tones can be superimposed over them.

The impacts of light are painted at the last moment. In some zones, the colors are not blended together, but left in their fresh and direct form.

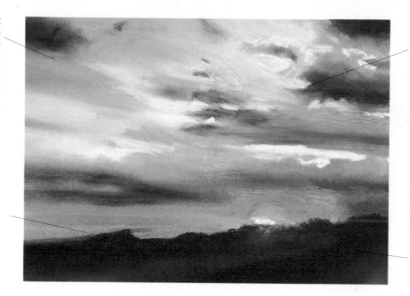

The area corresponding to the horizon is painted in orange and pink tones that are blended in over the first.

The most radically dark areas are painted in black and strongly contrast with the most colorful areas of the sky.

Harmonizing with the Color of the Background

The color of the paper, upon being integrated into the color scheme of the painting, may be the basis for establishing the range of colors to be used to represent the subject. For example, in the exercise that is going to be developed to follow, we are going to paint over a tobacco colored paper. All of the colors used belong to the same family and for this reason they will establish a beautiful harmony among themselves.

The contrasting lights and shades are applied at the last minute in order to redefine the forms and outline the bird. As can be seen, the original tone of the paper breathes through all of the colors that have been applied and at no times falls out of harmony. The paper acts as a bonding link among all of the colors of the painting.

FOLESHILL